TSONG PU

莊普個展

OFF-ROAD AURA

越野的靈光

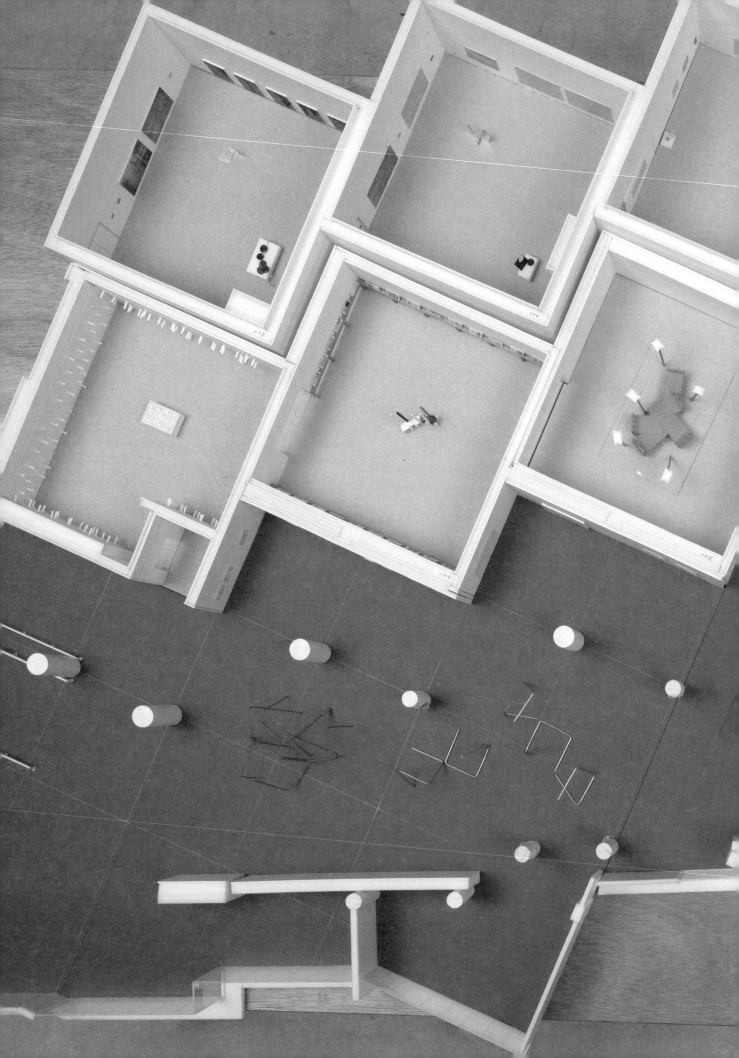

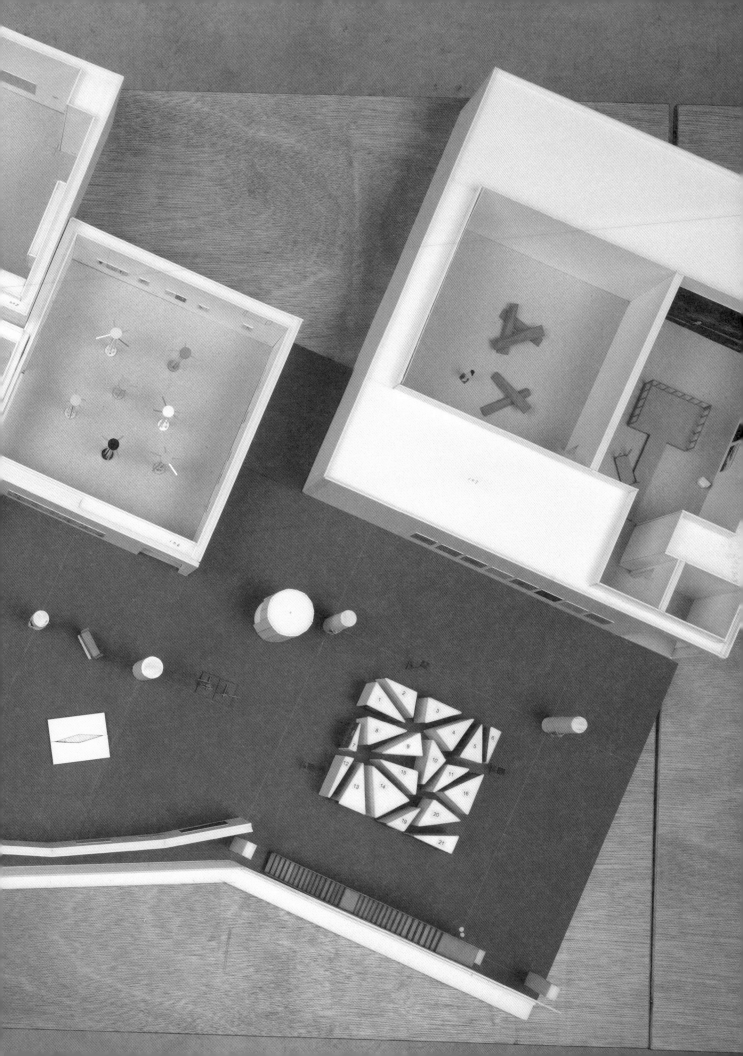

目次

Contents

「越野的靈光：莊普個展」館長序

國立臺灣美術館長期致力於「重建臺灣美術史」，積極籌辦臺灣重要藝術家個展，並透過典藏機制、出版研究及教育推廣等途徑，持續建立臺灣美術史的知識體系。今年度，國美館擬擴張臺灣美術史的時間維度，辦理80年代後崛起之藝術家莊普個展，將當代藝術的面貌納入臺灣美術史的研究範疇。

藝術家莊普1978年畢業於西班牙馬德里大學藝術學院，80年代回臺後積極從事藝術創作，並與陳慧嶠、劉慶堂等藝術家共同創立「伊通公園」（IT PARK）藝術空間，積極帶動臺灣當代藝術風潮。於1983年舉辦首次個展「心靈與材質的邂逅」，創造出觀看物質本身存有的嶄新情境，而1985年的個展「邂逅後的誘惑」，以一公分見方的木章印記，在極簡與繁複的視覺構圖間創造多重的空間感知，成為莊普日後為大眾所知的美學印記，並於2019年獲得國家文藝獎殊榮，可謂臺灣當代藝術重要代表人物之一。

此次「越野的靈光：莊普個展」邀請石瑞仁擔任策展人，集結莊普40年來的作品。觀眾可一睹其西班牙留學時期的早期作品〈無題〉與〈五張貼紙〉，現地重製1980-90年代經典低限作品〈來去自如遨遊四方〉，藝術家創作靈光的起源〈逃離現場〉，以及印記繪畫風格的代表作品〈邂逅後的誘惑 II〉等約百餘件作品。展覽範圍遍及美術街、103-107展覽室以及203-205展覽室，於美術街展現莊普應用如金屬、木料、紙張等材質創作的裝置作品。而〈即刻峇里島〉則是莊普以各樣材料形構成睡瑜珈的姿勢，用以慰勞美術街支撐建築結構的柱體之幽默新作。

面對多元的創作形式，策展人石瑞仁以「越野的靈光」為觀眾導航，破題點出莊普兩條創作路徑的交會與發展，從純藝術、理性的視覺結構，如〈邂逅後的誘惑 II〉，到回歸日常，不時表達對自身時代的觀察，如作品〈五月〉簡約結構中隱含社會階級的辨識；而早期作品〈真愛不滅〉則可看出藝術家對真愛的玩味反擊。本次展出包括平面繪畫、裝置、雕塑、錄像等，時而詼諧、時而簡練、或富有寓意的風格，完整呈現藝術家40年的創作歷程與理念。

1980年代臺灣社會風氣逐漸自由開放，讓當代藝術家勇於運用更多樣的媒材與嶄新的表現形式，其中更包含了藝術家對社會的觀察與回應。在文化部指導下，國立臺灣美術館期待藉由「重建臺灣美術史」的計劃，更完整呈現臺灣美術各時期的藝術風貌，持續梳理典藏的研究脈絡，進一步擴延公眾對臺灣美術發展的認知與想像。

國立臺灣美術館館長

陳貺怡

"Tsong Pu: off-Road Aura"
Director's Foreword

The National Taiwan Museum of Fine Arts (NTMoFA) has long been committed to "Reconstructing Taiwanese Art History," proactively organizing solo exhibitions of pivotal Taiwanese artists. Additionally, we continue to build a knowledge system of Taiwanese art history through methods like museum collection, scholarly publication, and educational promotion. This year, the NTMoFA endeavors to extend the temporal dimension of Taiwanese art history by staging a solo exhibition for Tsong Pu, an artist who rose to prominence after the 80s, thus integrating the aspects of contemporary art into the research of Taiwanese art history.

Tsong Pu graduated from the Real Academia de Bellas Artes de San Fernando in 1978 and returned to Taiwan in the 80s, fully dedicating himself to art. Along with artists including Chen Hui-Chiao and Liu Ching-Tang, Tsong co-founded the IT PARK art space, becoming an instrumental force in catalyzing Taiwan's contemporary art movement. His first solo exhibition in 1983, "A Meeting of Mind and Material," introduced a fresh lens for exploring the essence of material. His 1985 solo exhibition, "Temptation after Meeting by Chance," employed one-square-centimeter wooden stamps to create a layered spatial perception between minimalist and intricate visual compositions. These became hallmark aesthetics for Tsong Pu, solidifying his reputation. In 2019, he was bestowed the National Award for Arts, affirming his standing as one of the luminaries in contemporary Taiwanese art.

"Tsong Pu: Off-Road Aura" features Shih Jui-Jen as the curator and assembles an array of works by Tsong from the past 40 years. Visitors can view early pieces from his time studying in Spain, like *Untitled* and *Five Stickers*, as well as classics from the 1980-90s such as *Nomadic*, *Escape the Scene*, which is the source of the artist's creative inspiration, and *Enticing Encounter II*, a seminal work emblematic of Tsong's iconic stamp-painting style, over one hundred works in total. The displays unfold across Gallery Street and galleries 103-107, as well as 203-205, displaying Tsong Pu's installations in a variety of materials, from metal and wood to paper. Among the pieces is *Instant Bali*, a new work that humorously employs various materials to mimic a reclining yoga pose, serving as a whimsical counterpoint to the structural pillars that anchor Gallery Street.

Faced with diverse creative output, curator Shih Jui-Jen navigates viewers through the works with the theme "Off-Road Aura," underlining the intersections and developments in Tsong Pu's two creative pathways, from purely artistic and intellectually ordered visual structures, like *Enticing Encounter II*, to an engagement with the quotidian while depicting periodic observations of his era, such as the socially diagnostic undertones in the minimal structure in work *May*, and his playful counter to the notion of true love in the early work *True Love Never Disappear*. Through paintings, installations, sculptures, videos, and a narrative that is sometimes whimsical, at other times succinct, yet always deeply allegorical, the exhibition offers a holistic view of the artist's four-decade-long creative odyssey and philosophy.

In the 1980s, Taiwanese society underwent a gradual liberalization, emboldening contemporary artists to experiment with more diverse mediums and innovative expressive forms, including socio-cultural observations and responses. Under the guidance of the Ministry of Culture, the NTMoFA hopes that the mission of "Reconstructing Taiwanese Art History" will offer a more encompassing representation of the artistry across various eras in Taiwan, continually refining the narrative built around our collections and thereby extending the public's understanding and imagination of Taiwanese art history.

Director of the National Taiwan Museum of Fine Arts

「越野的靈光：莊普個展」── 畫語與物語的競合

策展人｜石瑞仁

莊普的藝術生涯，從 1980 年代以迄 2023 未曾中輟，40 多年來的創作發展，立基於極簡美學的觀念和藝術實踐，從頭即打造了個人旗幟鮮明的視覺形式和風格路線，接著在不同的年齡階段和生活體驗中，他的創作也出現了兩大脈絡的分化和演變：其一是，對於「極簡抽象」的繪畫美學延展，他不斷嘗試各種加料和加碼的方式，不斷擴充變奏曲式的概念，也一再成功地證明了，他那「印格」標記鮮明的「莊記畫語」系統，其實很有能力「將極簡繪畫，無限地演繹、繁殖、擴張」的意圖和旨趣；其二是，基於「即事──格物」的開放態度，讓個人心思融入生活萬象，被動地去感受和吸收，也主動地去旁敲側擊時代與環境的點點滴滴，從而在其平面繪畫系統之外，另行開闢了一條可概稱之為「莊氏物語」的立體創作路線。

本展策劃，以「越野的靈光：莊普個展」為展題，內容主軸即在於鋪陳莊普以極簡美學來建構個人現代藝業之前提下，又如何平行發展出讓自我心思和當代社會、生活、文化之間，不斷地呼應或對話的各類「當代性」創作。

靈光，是讓觀者從藝術品中感悟的一種意象、氛圍、或機制。優秀的藝術家，往往也是個靈光的生產者。如神人點石成金，如巧匠化腐朽為神奇，莊普早期的畫作，即偏愛「讓材質自己說話」，中後期的創作，更擅長讓一些尋常的事物，在他的作品中，轉化成訊息的載體，或變身為引人興味的對象。「鈍物」之所以能讓人「頓悟」，正因為他在經意和不經意中，注入了某種「靈光」的氣息。靈光，也是激發創作者奮起而作、自我突破的一種思緒、靈感、事物、或情境。俗諺說「好奇會殺死貓」，但是，慣性的思維和行動，反而會讓創作者的藝術生命「無疾而終」。90 年初，莊普創作突增的擴散性思維和跳躍式表現，著實反映了這樣的自我期許──唯有勇於「翻牆」，敢於「越野」的人，才會邂逅新的靈光，發現繼續前進的道路，以及向上提升的關鍵。

「越野」的基本概念就是「道路之外，另闢新徑」。相對於在鋪面平整、線道明確、設施完備、標誌清楚的正規道路上走路、跑步、騎車、或開車，「行不由徑」而兼具運動、休閒、探險、尋奇等性質的「越野」行動，顯得更自由、更好玩有趣、更接地氣、更能體驗、融入周邊的各種環境。越野的行程也許充滿未知、但也因此能啟動不同的身心挑戰、激發一波又一波的自我超越。

本展題旨，除了借用「越野」的精神概念來類比並詮釋莊普的藝術發展歷程，作品的呈現，也特地從其「一心一意」型的架上繪畫，和「三心二意」式的立體創作中，分別挑選出一些各具自明性，又能呈顯出某種相互競合意趣的作品，來規劃此展。如此，希望有助於觀眾從中體會，莊普長年來不斷克服「創作瓶頸」之道，就是針對內造與外塑的框構系統、慣習思維、窠臼路徑，一方面能自我解放地做逃生實驗和野外尋寶，另一方面又能不忘初心地跑回賽道中，為感覺弱化的本體和靈光繼續輸血與充電。

進入 21 世紀，全球化、多元化、資訊化、即時化、複製化 …… 等概念，已經變成了當代文化及社會環境中的日常現實，識者因此指出，藝術品特有的「靈光」從此不再是體認其價值與意義的重點，對此，莊普個展的啟示就是，當代藝術家終須正向面對這種趨勢和挑戰，起心動念就在於──如果「範式轉移」是必然的文化發展趨勢，不妨用勇敢「越野」的心態和行動，來開啟新的「靈光」，來發展新的藝術視野和全景。

「莊記畫語」的生發與成形

「莊記畫語」的起源，可回溯到 1983 年，莊普於臺北春之藝廊發表的首次個展「心靈與材質的邂逅」。此展在創作的媒材技法和藝術的形式內容等各方面，都具現了前衛創新的思維和實驗探索的態度。以媒材和技法而言，其中最核心的概念和實踐，就是「以破為立」，例如，在畫好棋盤式小方格的畫布或畫紙上，用針線一格格地對角紮縫，或將紙面用美工刀一片片地割劃、挑撕，或在卡紙上交織異質的條狀皮革等等，這些都是藉由破壞性加工，在既有的素材平面上創造出「另類真實」和「異趣美感」的不同表現手法。但就形式和內容看，此展的所有作品，僅僅執著於抽象純粹的媒材表現，而完全放棄了模擬再現的圖像和故事敘述的內容。針對這批唯心導向和唯覺性質的藝術成果，莊普也很篤定地申明了：「我深信內在世界，可能比肉眼所見的世界更真實。繪畫只要完成自己就好了。」

不過，真正奠定「莊記畫語」之風格路線和記號系統的，應屬 1985 年中，莊普再次於臺北春之藝廊舉行的第二次個展「邂逅後的誘惑」。此展中，莊普藝術發聲的重點，就是「個人記號的建構和主張」。此展首次發表的「印格畫」，可視為先前探索「材質表現可能性」的一個延伸，但是以「表面戳記」的行為取代了「實質破壞」的行動。從執行面看，他以邊長一公分的小方印取代畫筆，沾上顏料後在畫布上一格格地以手戳印，相較之前在畫面上的方寸之間細心進行縫、織、割、挖、刻、揭、折的各種手藝式操作，戳印無疑是最簡易而直接了當的表現手法，但也正是從這一塊塊看來不甚均整、但是可以無限延伸，也可以重重疊加，可以低調極簡，也可以華麗有加的色彩戳記中，莊普當下發展出了其「抱朴守一、旗幟鮮明」的印格畫系統。

莊普的印格畫，除了畫廊展出成功，媒體口碑極佳，也馬上獲得了當年的「雄獅雙年獎」。針對其新畫風，推薦他獲獎的評委呂清夫特別寫道：「……像他這種乍見單調、混沌的畫面、或不為形役的、非焦注的作品畢竟實驗者少，而實驗精神正是我們所欣賞的，我們應給不拘形式、不拘模式、不囿於通俗流行、不囿於自然外形的自由精神投上一票。」

莊普的印格畫，看似最無技術門檻，卻一戰告捷式地打開了一條頗受肯定的藝術新徑。對此，詩人羅門的解釋是：「……他在畫面上，清理出相當單純、潔淨、舒暢與開放的視覺空間，具有高度的適應性，能迅速地引領現代人的眼睛進入視覺活動的『快車道』與『高速公路』，而在潛意識中感觸到一切在活動中的『前衛性』。」

「莊氏物語」的濫觴與開展

1989 年，莊普應邀回到留學國西班牙，在馬德里東南方人稱「最美麗的城市」關卡 (Cuenca) 舉行了一次個展，展覽名稱「一棵樹‧一塊岩石‧一片雲」，借自美國孤獨作家卡森‧麥卡勒斯 (Carson McCullers, 1917-1967) 的同名短篇小說，裡面有個尋找失妻的酒鬼，跟送報童說了一段啟人心思的話語「愛情要從愛上一件實際的物品開始，比如一棵樹、一塊石頭，或者一片雲，而到最後，你就能輕而易舉愛上所有的東西，以及任何一個陌生人。」把「愛情」這兩個字換成「藝術」或「創作」再讀一次，也許可藉用來理解當時的莊普，除了繼續「一心一意」地創作無關現實的極簡繪畫，也試圖從生活感受中，同時發展出一些比較隨心適意，乃至

可以「三心二意」的非系統性創作。

次年，莊普於臺北市立美術館發表的「軀體與靈魂之空間」個展，可稱是「莊氏物語」型創作具體展現第一個里程碑。根據我個人當年的觀察和評論中，此展可以理出幾個轉折性的重點：

（一） 日常材料的運用：此展作品並用了許多質性或屬性對比的日常材料，例如布與鋼條、報紙與鋼片、樹枝與鋁條、鑄鋼與泥土 …… 等，對於「材料」美學的主張，雖是其 1983 年首展理念的延伸，但藝術家處理材料的心思和態度，已由原先的「征服與製造」轉為「尊重與協調」。

（二） 自由形式的發展：由於創作過程中，藝術家幾乎不再「動手」對物料進行雕鑿塗飾，而改以格物觀照或即與頓悟的方式來組構作品，整個展覽因而似無統整的形式和風貌，但強烈呈現了一種「自由發聲、多樣表現」的基調。

（三） 內容訊息的導入：此展顯示，莊普試圖在作品的抽象形式語言中，融入社會人文的內涵。許多件作品很明顯的是藉物言事，除了材質、形式的表現之外，也負載了某種內容性的意義。內容上的任何指涉，是莊普過去作品中所排斥的；形式的多樣表現，也大異於他已眾所熟知的那種均質化、商標化的印格繪畫。概觀此展的全新意趣就是，以立體裝置的手法，藉著材料的演出，反應了莊普個人對人物與社會、自然與環境、史事與時局等各方面的心思。另一要義就是，正式宣告了讓創作與生活重新磨合，一個可稱之為「莊氏物語」的創作取向的來臨。

「畫語」和「物語」的競合

2001 年，莊普在伊通公園發表的「非常抱歉」個展，把代表「莊記畫語」和「莊氏物語」兩種屬性的十組系列式作品，做了同場競秀和磨合的一次集結。在該展的觀察評論中，我也提出了莊普創作進入 21 世紀之後，自由無礙地優游在現代的「記號性系統」和當代的「符號性世界」的一種藝術姿態。並在結論中點出了，透過這個「非常抱歉」展，莊普要說抱歉的原因就是，他已經把人們對其創作的慣性認知和片面印象全然推翻了！

展覽規劃與作品鋪陳

一、美術街：走過當代藝術大街 – 體驗多元美學風貌

美術街，有高挑的空間、斜長的通道、和一根根的大圓柱；左側有五間展室一路相連，右側能看到窗外藍天。這是一種有別於「白盒子」藝術空間的另類展覽場，也是國美館中最神似現實生活世界的一個「環境式空間」。本展規畫和作品配置，立意將美術街就地轉化為一個琳瑯滿目、後現代文化情境的藝術大展場，讓觀眾在逛街過程中，輪番啟動旨趣不一的藝術感知經驗。美術街概要集結了莊普創作的多元觀照和不同款式，也提供了三種現場體驗模組：

（一）　在街道空間中，遇見接力出現的立體雕塑與裝置作品；以尺寸和規模比，有
　　　　超大與迷你、頂天與貼地、單體和群聚的對照；就媒材與技法看，含括了基
　　　　礎金工、木工、鐵工、水泥工的應用與昇華；就形式與內容看，從純藝術的
　　　　抽象造型體，逐步轉進到指涉社會、文化、政治的寓言式裝置。

（二）　順著展間外牆，一路觀賞不同類型與風格的平面作品，包括純視覺訴求的極
　　　　簡抽象畫作、集體記憶連結的社會性影像作品以及混搭了生活物件與平面畫
　　　　作的複合媒材創作。

（三）　在現場的 7 根大圓柱上，探索莊普將瑜珈健身體姿轉化為據地藝術裝置的
　　　　〈即刻峇里島〉不同版本。

概觀，美術街「畫語站兩旁、物語擺中央」的作品鋪陳，可視為莊普創作的大鳴大放區。多元
的內容指涉和多樣的風貌呈現，可從下列的作品解說做更深入的理解：

〈來去自如遨遊四方〉(1985)，此作是以圓形不鏽鋼條製作的線性雕塑／空間裝置，單一的造
形單元，可擺出四種不同的姿態，並以此構成群組化的地面裝置；必要時，也可透過更多組件
的組合和延伸，與不同空間環境進行對話。值得注意的是，此作的虛空輕盈特質，巧妙地平行
對應了同年度林壽宇用厚實沈重的鋼板製作的雕塑裝置〈我們的前面是什麼〉。一虛一實的兩
種套路，反映了兩位藝術家切入雕塑領域和裝置創作的不同思路和實踐。

〈三竹節〉(2022)，透空的線性立體造形裝置，此作以工業用角鋼材料製作，乍看似自由抽
象造形的表現，其實已同步優化了結構力學的功能需求。再看，此作呼之欲出的自然風情顯示
了，莊普有意讓此作「多說一些話，多給人一些想像或驚喜」。觀者如果知道有一種擬態竹枝
的昆蟲叫竹節蟲，就不難意識到，這組把玩工業風的作品中，其實也「擬態」地注入了三隻昆
蟲正在互別苗頭的自然戲碼。

〈五月〉(1990)，是莊普寓寫臺灣政治現象的一件早期代表之作；材料的運用及形式安排相當
地簡約素樸，但是充滿了隱喻的趣涵。全作以一束鋼柱與一群泥團各自圍成兩個圓圈的交集，
暗示了大小兩股勢力的互動與折衝。向天矗立而略嫌鬆散的鋼柱群，意味了一個有待自我穩固
和強化的大體制；貼地集結成圓圈的一群小泥球，象徵了一種正在類聚整合的基層力量。這種
藉物寫事的手法顯示，莊普創作對於社會議題的針對或呼應，是「微言大義而不煽情」的。

〈1997 紀念碑〉(1996)，莊普歷年創作中，具有「紀念碑」意旨和名稱的作品，最早的是用七
支鋤頭挺立一片大鋼板的〈勞動紀念碑〉(1990)、最近的是用六萬顆骰子黏組成的正方體〈Si
Ba La 紀念碑〉(2008)。本次展出的〈1997 紀念碑〉，是他當年應邀至香港參加「中國旅程
97──兩岸三地的裝置藝術展」展覽的現地製作。此作以水泥和沙漿，為「1997」這個全球關
注的歷史年份造碑和刻銘，水泥也同時鎖死了指涉兩岸三地的一張桌子和兩把椅子。藉此，莊
普在「紀念碑」的形體和概念中，盡在不言中地注入了「墓誌銘」的意涵。

〈召喚神話〉(2013)，此作以二十多座幾何抽象的三角柱造形體，結合懷舊意象的各色木製門
窗，在美術街尾端，打造了一個臺灣昔日眷村聯想的住宅聚落。觀眾可以從不同方位乃至空覽
角度，瀏覽各家各戶同中有異的老舊風情；也可以側身走入用來區隔和連通家家戶戶的緊迫通

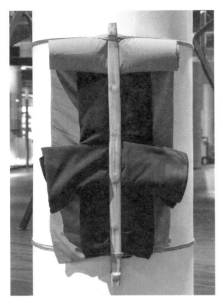

圖 1

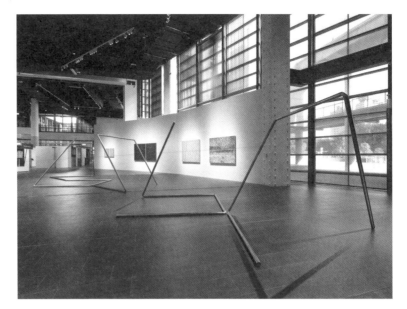

圖 2

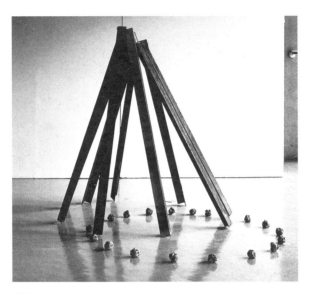

圖 3

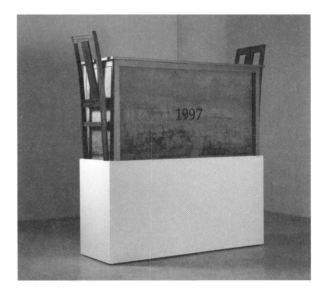

圖 4

<u>圖 1</u>　即刻峇里島，2023，扁擔、毛毯、麻繩、瑜珈墊，尺寸依場地而定，藝術家提供。

<u>圖 2</u>　來去自如遨遊四方，1985，不鏽鋼，尺寸依場地而定，藝術家提供。

<u>圖 3</u>　五月，1990，角鐵、陶土，尺寸依場地而定，藝術家提供。

<u>圖 4</u>　1997 紀念碑，1996，水泥、木桌椅、展台，166×170×58 公分，國立臺灣美術館典藏。

道中，貼近體會人去屋空，復國共業徒成往日神話的一種唏噓情境。概觀，此作以一種嚴肅靜默的氛圍和看似「斷捨離」的形制寫照了 —— 分崩離析的諸多元素，兀自等待著重新凝聚為一大整體的，某種召喚的力量。

二、1F 展區：103-107 展覽室

一樓從 103-107 五個室內展場，各有獨立空間而又一路相連；本區展品的選擇與配置，希望讓觀眾順著動線行進時，可以一路對照觀賞平面的「莊記畫語」和立體的「莊氏物語」之間，不同而有趣的對話。概要地說，「畫語」的屬性就是作者中心論和藝術中心論，是一種系統性繪畫的自我延伸；而「物語」的起點則是生活中心和現實感應，每件作品看似順手拈成而沒有規則可尋，手法多元而形式不一，出奇制勝而不成系統。很明顯，「畫語」是在一個自我訂定的道路上不斷向前衝刺；而「物語」則是三不五時地，因為「感時花濺淚」、或因「恨別鳥驚心」的種種誘因，而衝出了跑道，遁入生活世界中去取材抒發的一種「越野」型創作。

本區選展的作品，依照空間及動線序，包括：

(一) 103 展覽室，整個房間，被轉化為一個環場型的壁面裝置，這是復刻莊普 1992 年作品〈逃離現場〉的現地重製。用日常經驗看，這好像是個「破壞的現場」，場中留有破壞碎片，牆面隱有血腥氣味；從藝術經驗談，這其實是個「歷史重塑」的現場，莊普藉此回溯、類比史前人類開始在洞穴中，用黑炭和紅血「做記號」的各種有意識行為，也提醒了我們 —— 文明發展的初始戲碼就是，「逃離創作現場，寫下歷史新頁」。

(二) 104 展覽室，場中的極簡裝置〈朗道〉(2017)，全作只用了直線的元素，看來幾何理性而完全抽象。四周牆面的平面作品《手的競技場》系列，是莊普於 1999-2021 年間，陸續完成的 30 組創作。《手的競技場》刻意以雙拼格式，呈現單色印格畫作與黑白手語照片的對照。概括地看，具象的手勢和抽象的畫作、造型裝置都屬於「視覺的語言」，但如果不懂這些手勢的指涉或手語的意義，《手的競技場》，主戲就指向了動感的手姿韻律，和靜態的藝術審美之間的一場視覺競秀，而不是其內容與符旨的「話語」辯論。

(三) 105 展覽室，場中的大型裝置〈在遼闊的打呼聲中〉(2005)，應用元素包括：緊密相嵌的五張單人木床、五根長木柱、五隻黑皮鞋、和五個白枕頭的組合。這些日常物件，是民眾熟悉的，作品的直接趣味及轉折意涵，例如，「同床 —— 不共枕」、「高枕 —— 無憂」、「同床異夢 —— 打呼共鳴」，也可能是民眾較易體認和聯想的。但此作也有伏筆和提問 —— 每張床顯然都有一隻皮鞋失蹤了，到底是各自夢遊去了，還是跑到夢鄉之外去遇合了？

(四) 106 展覽室，〈光塵呎度〉(2022)，以工匠必備的魯班尺 (捲尺)，作為裝置結構和造形的主要元素。每組十支捲尺，輕盈地聳立在頂天立地的兩片圓木板之間，如擎天立柱也像噴泉水瀑；七十隻捲尺的陣列，集體演示了「力與美」的完美平衡。莊普「越野」式的靈光，於此表現在「讓日常物昇華」的舉動。在平常的認知中，藝術就是光，工具只是塵，但此作慧心演示了「和光同塵」的趣涵，成功地讓「應用的工具」華麗轉身，就地變成了「藝術的

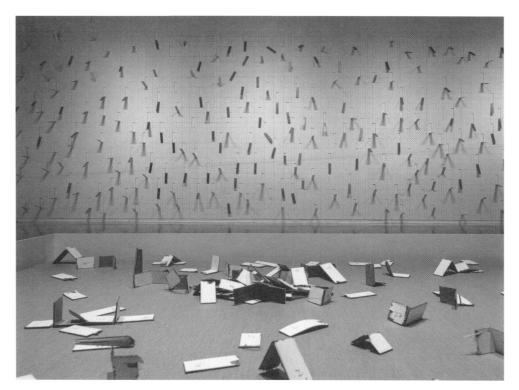

圖 5　逃離現場，1992，木材，尺寸依場地而定，藝術家提供。

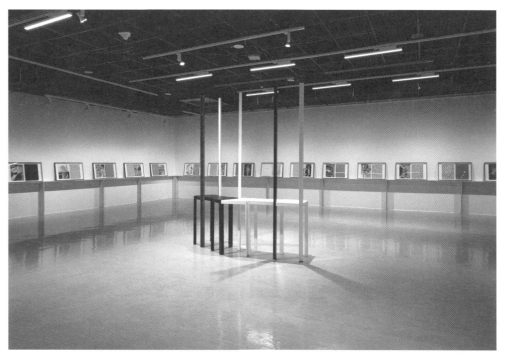

圖 6　手的競技場，2021，複合媒材，49.6×84.1×3.6 公分 ×30 件，國立臺灣美術館典藏。

本體」。彷彿就在丈量空間尺度的工作過程中，藝術家突然喊了一聲「卡」，將這個「物質化的時間凍結」複製、繁衍到一種空間的規模後，「空間尺度計量」也有了「藝術高度演示」的戲劇性姿態。相較之下，106 室牆面同樣大小規格的一批方形畫作系列，戲碼就不是直接轉化，而是刻意用類比手法擬仿數位效果，並用極簡美學的絕對知性來疊合抽象表現的隨機感性，這種「腳踏兩條船」的手法，針對也挑戰了抽象繪畫之冷與熱、理性與感性、節制與隨機的二元論，可視為莊普跳出抽象藝術的道路區分而「越野」創作的一種混血新品。

（五）107 展覽室展出的「新店男孩」系列，是莊普與陳順築、吳東龍、蘇匯宇共四位藝術家，於 2012 至 2016 年間的共同創作。右側展出的單頻道錄像作品〈生活的決心：最好的一天〉，以一鏡到底和定點兩次環場掃描，錄下四位藝術家於烏來山區的溪流中，徜徉於自然山水情境，共享同儕互動情誼的行為演出；展出時則以慢速無聲的影像和無縫循環播放方式，強化了慢活、樂活與詩意的情境。或許，可視之為古代文人雅集活動「蘭亭修禊、曲水流觴」的一個臺灣當代變奏體式。左側區展出的〈星際迷航〉，是三頻道同步的超寬景錄像投影，慢速播放的黑白影像，擬仿了復古科幻電影的調性，藉由太空敘事，指涉人類世界的荒誕與虛無。影片中的景物，聯結了李再鈐抽象雕塑遭受政治霸凌的陳年往事，和新店溪流域因颱風之害，而從美麗家園變成陌生異域的現場情境。於此，莫須有的人禍和天災，儼然是「星際迷航者」登路觀照本土的第一印象。

三、2F 展區：203-205 展覽室

二樓展區，順著 205、204、203 的空間動線規畫，作品的選擇和鋪陳，旨在打造以「莊記繪畫」為主軸的一個藝術通廊。

莊普早期作品，以長寬各一公分的顏色方塊，作為畫作的基本元素。圓點或方塊，原只是一種中性的標記，然而，正如草間彌生收編了圓點，莊普也率先搶佔了方塊，把本來不具特定意義的幾何方塊，藉由蓋章的概念和手工操作，當下轉化成為一系列不必簽名也知道作者的記號性繪畫，此即本次策展概稱的「莊記繪畫」。三間展室的關連與區隔是：205 大體呈現了「莊記繪畫」隨著時間而不斷演繹發展的自然進程；204 取樣呈現了莊普一再試圖將極簡繪畫帶到某種「極致性」境界的一些心思和成果；203 如實呈現的是現階段最新畫作的風貌。

205 展覽室展出 16 件作品，包括 14 幅畫作和 2 件裝置。這些畫前後橫跨了半個世紀，可視為莊普心路歷程的縮影。

最早的〈無題〉(1977-1982) 和〈五張貼紙〉(1978)，是他西班牙留學時期的素描作品，隱約雛現了後日創作的雙軌路線：一個是從現實面（此處為衣物照片）出發的再創；另一件純抽象素描，已可看到「在眾多制式小方格中重覆繪畫勞動」的創作概念。

〈消散的近景〉(1982)，開始把顏料當成砌磚來應用和表現，一塊一格，限用單色和單一技法，已經有意把繪畫行為極簡化為一種「允許質變的量化填彩勞動和遊戲」；〈邂逅後的誘惑 II〉(1985)，就是此道技法完熟、自成經典之作。

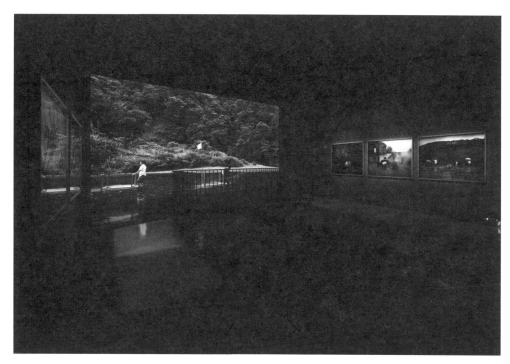
圖 7

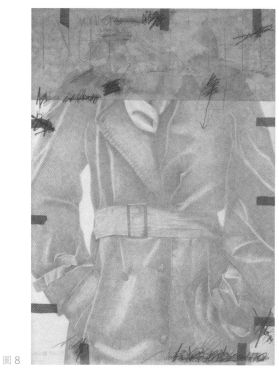
圖 8

圖 9

圖 7　新店男孩（陳順築、莊普、吳東龍、蘇匯宇），生活的決心，2012，單頻道錄像、攝影、裝置作品，
　　　　尺寸依場地而定，臺北市立美術館典藏。

圖 8　無題，1977-1982，素描，105×75 公分，李道明收藏。

圖 9　消散的近景，1982，油彩、畫布，190×130 公分，私人收藏。

《月落‧日出》(1986) 系列作品顯示，莊普試圖在雕塑、裝置、現成物這些領域中，有一番不同的作為，原先的極簡與制約，也因此開始容納有機與開放的質素；簡單的如〈掛著〉(1989)，將平面畫作重重交疊並外掛樹枝；複雜的如〈真愛不滅〉(1993)，直接以電影海報為創作材料，將原畫面分格細割，再由內往外不規則地翻折出長短紙條，加上一些信手塗鴉，形成了大量的「白噪音」，澈底干擾了原畫面影像的言說作用。透過玩手藝，莊普針對標題文字的愛情神話，做了既直接也幽默的破解和回應。類此，「越野」的靈光，有時就是透過破解言語來產生的，〈閃耀之交會〉(2008)，一方面可視為對自我畫語風格的破解 —— 但見，扁平成性的「莊記」印格畫面中，竟然憑空出現了兩點透視的深度空間感覺；但另一方面，即使到〈鳴泉飛瀑〉(2020) 仍可發現，莊普其實是使用直線與橫線，來製造出各種「斜線」交會的錯覺。他謹守的另一原則就是，堅持用低階的手工，來抵制數位時代中，所有圖畫和影像，都可以透過像素來製作再現 (也因此導致靈光消失) 的技術革命。

在 204 展覽室，展品鋪陳聚焦在莊普的印格繪畫，以水平思維模式進行擴散式探索的不同畫例。例如：1999 年的〈因觀〉、〈霜彩〉，探索如何創造「如恆河沙、如銀河星」的不可勝數之美境。2008 年的〈內在的座標〉與〈散播的資訊〉，探索能否營造一種「密不容針、疏可跑馬」的視覺叢林。2014 年的〈看不見的風景層〉、〈綠遍山原白滿川〉與〈鳴〉，是有關於「動態與不定形」的探索。

最後，203 展覽室的作品鋪陳，全都是 2023 最新完成的畫作。1986 年《月落‧日出》裝置系列，於此更像是用來申明 —— 昔者已如月落，今者正如日出。對莊普而言，創作就是應該「苟日新，日日新，又日新」吧！

Tsong Pu : Off-Road Aura, Painted Poem vs. Objects Talk

Curator | Shih Jui-Jen

Tsong Pu has never abandoned his career as an artist since the 1980s. The philosophy and practice of minimalist aesthetics have been at the core of his oeuvre development that spans more than four decades. No sooner did he embark on his artistic career than he established his inimitable visual style. Based on his personal experiences at different stages of his life, Tsong's works have ramified and evolved into two particular contexts. The first is the extension of the painting aesthetics of "minimalist-abstraction." The artist continues to expand his variation-like creative concept by experimenting with a riotous profusion of materials and additions, and his signature "Tsong-style painted poem," characterized by an elaborate grid system of seal imprints, has ergo proven well capable of "infinitely interpreting, reproducing, and expanding minimalist paintings." The second context is the open-mindedness based on "confronting things and studying their nature." It enables the artist to attain the oneness of his mind and all manifestations of his life. He not only passively feels and digests the time and the environment, but also actively makes indirect inquiries into their components, thereby blazing a trail in 3D creation that can be aptly termed the "Tsong-style objects talk" apart from his graphic system.

Titled "Tsong Pu: Off-Road Aura," this solo exhibition not only outlines how the artist premises his personal artistic career on minimalist aesthetics, but also revolves around how he creates different yet parallel art series that embody the spirit of "contemporaneity" and allow his mind to resonate or dialogue with contemporary society, life, and culture.

An aura refers to the imagery, ambience, or mechanism that the viewer appreciates from a work of art. An artist par excellence tends to be an aura producer. In his early paintings, Tsong preferred to "let the materials speak for themselves," just like a prodigious man having the Midas touch, as well as a skilled artisan able to make a silk purse out of a sow's ear. During his mid and late career, Tsong's works were marked by his gifted transformation of ordinary objects into vehicles of messages or something thought-provoking. Whether deliberately or unintentionally, Tsong infuses his works with a certain aura, which is why the viewer may experience epiphanies from these run-of-the-mill objects. An aura is also an emotional state, inspiration, thing, or situation that spurs an artist into vigorous creation and self-breakthrough. "Curiosity killed the cat," says the proverb. However, ideological and behavioral inertia will render an artist's career finished nowhere. In the early 1990s, the surge of Tsong's diffusive thinking and non-linear expression manifested in his works did reflect his self-expectation—only those who dare to "climb over the wall" or "go off-road" will encounter new auras that beckon, encouraging them to keep moving forward and find the key to enhancement.

The term "off-road" basically implies "blazing a trail off the road." In comparison with walking, running, riding, or driving on regular roads with smooth pavement, complete facilities, and clear markings and signs, "off-road" activities that fuse the elements of sports, leisure, and exploration together appear freer, more delightful, and more down-to-earth, allowing people to better experience various surroundings and blend in with them. Whatever one thinks of the ultimate destination, the off-road journey is definitely worth the ride, because it not only poses exciting physical and mental challenges, but also helps achieve personal mastery.

This solo exhibition appropriates the spirit of "off-road" to analogize and interpret the course of Tsong's artistic practice. The exhibition planning and installation give special prominence to the self-evident works of competing charm among the artist's "single-minded" easel paintings and "open-minded" 3D creations to help the viewer comprehend how the artist has continually made breakthroughs over the years. In the face of the framework systems, inertial thinking, and stereotypical approaches, be they endogenous or exogenous, the artist on the one hand conducts escape experiments and treasure hunts in a way of self-liberation, and on the other hand keeps recharging his dulled noumenon and aura by returning to the racetrack without forgetting why he started.

As we enter the 21st century, concepts like globalization, diversification, immediacy,

informatization, and replication have become part of our quotidian existence in contemporary culture and society. Therefore, informed observers have pointed out that the "auras" emanating from works of art are no longer the key to recognizing the latter's value and deciphering their meanings. Against the factual background, this solo exhibition reveals that contemporary artists must, by all possible means, take the bull by the horns and overcome the aforementioned challenge. Actually, Tsong's idea is as follows: if a "paradigm shift" is an inevitable trend of cultural development, why not act in an adventurous, "off-road" mindset to create new "auras" and open up fresh horizons and vistas of art?

The Genesis and Formation of the "Tsong-style Painted Poem"

The evolution of the "Tsong-style painted poem" can be traced back to 1983 at the Taipei-based Spring Gallery, where Tsong Pu staged his first solo exhibition "A Meeting of Mind and Material," in which his avant-garde, innovative thinking as well as experimental, exploratory attitude found expression in terms of material, technique, form, and content. In that exhibition, "creating by breaking" was the kernel of concept and practice on the part of material and technique. For example, after drawing checkerboard-like squares on the canvas or paper, the artist either sewed diagonally with needle and thread square by square, cut and tore the paper with a utility knife piece by piece, or wove heterogeneous leather strips on cardboard. Through such destructive processing, his expressive technique, which was nothing if not kaleidoscopic, created "alternative realities" and "sui generis aesthetics" on the surfaces of given materials. However, in terms of form and content, the works displayed in that exhibition focused solely on abstract, pure presentation of media without representing any image and recounting any story. "I'm convinced that the world seen with our mind is more real than that seen with our naked eyes. Painting is all about fulfilling the Self," Tsong has confidently made it clear over this batch of works as idealistic as awareness-oriented.

However, it was not until 1985 when Tsong staged his second solo exhibition "Temptation after Meeting by Chance" at the Spring Gallery again that the style, approach, and sign system of the "Tsong-style painted poem" were fully established. What featured in that exhibition was the "construction and advocacy of personal signs." His "seal-imprint paintings" debuted in that exhibition could be regarded as an extension of his previous exploration of "expressive possibilities of materials," although these paintings substituted "seal imprints on the surface" for "substantial destruction." In terms of execution, the artist used the 1-cm² wooden seals he invented as his paintbrush, leaving imprints of pigment on the canvas with his hand square by square. Tsong's previous works embodied his fine craftsmanship of sawing, weaving, cutting, digging, carving, lifting, and folding. By way of comparison, seal imprints undoubtedly served as the most straightforward technique of expression. Appearing not much neat and tidy, these imprints could nonetheless be extended and superimposed infinitely. They could be either subdued and minimalist in style or drop-dead gorgeous in appearance. It was amidst these colorful imprints that the artist developed his inimitable seal-painting system that "embraces simplicity and maintains oneness."

The press led a paean of praise for Tsong's seal-imprint paintings in the successful gallery exhibition, which soon earned him the "Lion Art Biennial Award" that year. About Tsong's new painting style, Lu Ching-Fu, the jury member who recommended Tsong for the award, specifically wrote: "...after all, non-formal, decentralized works that experiment with compositions as monotonous as chaotic at first glance like his are thin on the ground, and such spirit of experimentation is exactly what we appreciate, so we should vote for the free spirit which is not bound by forms, modes, and popularity, as well as by natural shapes of things."

Seemingly having the lowest technical threshold, Tsong's seal-imprint paintings have successfully opened up a new and widely acclaimed avenue of art in one go, for which poet Luo Men offered his explanation: "…in terms of composition, he creates a highly adaptable visual space which is nothing if not simple, clean, delightful, and unrestrained. It can rapidly lead modern eyes onto the 'fast lane' and 'highway' of visual activities, and subconsciously sense all the manifestations of the 'avant-garde' in the activities."

The Origin and Evolution of the "Tsong-style Objects Talk"

In 1989, Tsong Pu was invited to Spain, the country where he pursued advanced training, and he staged his solo exhibition in Cuenca, known as the "most beautiful city" lying to the southeast of Madrid. The exhibition title — "A Tree, A Stone, and A Piece of Cloud"— was a namesake of the short novel authored by American writer Carson McCullers (1917-1967). The novel contains an enlightening dialogue between a paper boy and an alcoholic in search of his missing wife: "Son, do you know how love should be begun? A tree, A stone, A piece of cloud. In the end, you can love anything. Everything, Son. And anybody. All stranger and all loved!" If we replace "love" with "art" or "creation" and re-read this dialogue, we may understand Tsong's thinking at that time; to wit, he followed his heart to develop non-systematic, "open-minded" creations on the basis of his life experiences in addition to "single-mindedly" creating minimalist paintings that have nothing to do with realities.

"The Space between Body and Soul," Tsong's solo exhibition hosted by the Taipei Fine Arts Museum in 1990, could be said to represent the first milestone of his works within the context of the "Tsong-style objects talk." Based on my observations and comments at that time, I collated three turning points out of the exhibition.

A. The use of ordinary materials:

The works in that exhibition showed ingenious juxtaposition of contrasting materials in our everyday world, such as fabric and steel bar, newspaper and steel sheet, twig and aluminum bar, as well as cast steel and earth. Although Tsong's proposition of "material" aesthetics was no more than a philosophical extension of his first solo exhibition in 1983, the artist's mindset and attitude toward materials have changed from "conquest and production" to "respect and coordination."

B. The untrammeled development of forms:

When creating his works, the artist hardly processed the materials manually and instead organized them either by observing them and studying their nature or by pursuing spontaneous epiphanies. As a result, the entire exhibition seemed to lack a unified form and style, yet it strikingly presented a keynote of "free voice and diversified expression."

C. The introduction of content and messages:

The exhibition demonstrated that Tsong sought to imbue the abstract formal language of his works with social and humanistic connotations. Many of these works apparently spoke through objects and delivered meaningful content apart from material and formal expression, even though references in terms of content had been rejected in Tsong's previous works. The kaleidoscopic forms also ran counter to his homogeneous trademark seal-imprint paintings as everyone knows. Overall, what was new in the exhibition was that it reflected Tsong's thoughts on people, society,

nature, the environment, historical facts, and the current situation. Another seminal role of the exhibition was that it formally announced the advent of the "Tsong-style objects talk," a creative orientation allowing for the reintegration of life and artistic creation.

Painted Poem vs. Objects Talk

In 2001, Tsong Pu staged his solo exhibition "I am Sorry" at the IT Park, which gathered together 10 series of works that contend in fascination and respectively epitomize the "Tsong-style painted poem" and the "Tsong-style objects talk." In my observational review of that exhibition, I described the artistic gesture with which Tsong's creations, as they enter the 21st century, freely and unimpededly navigate between the modern "seal system" and the contemporary "symbolic world." I concluded my review by inferring that Tsong was sorry because he had completely subverted people's habitual perceptions and stereotypical views about his works.

The Planning and Installation of This Solo Exhibition

A. <u>Gallery Street: Strolling the Street of Contemporary Art, Encountering the Multifaceted Landscape of Aesthetics</u>

In the National Taiwan Museum of Fine Arts (NTMoFA), Gallery Street comprises a high-ceilinged space, a long, slanting passage, and huge columns. Five galleries stand in a row on its left side, and the azure sky is visible through the windows on the right. Appearing as an alternative exhibition space far removed from the conventional "white cube," Gallery Street is an environment that bears the closest resemblance to those in the real world. The purpose of the planning and installation of this exhibition is to transmute Gallery Street into a great venue brimming with a dazzling array of exhibits and an atmosphere of postmodern culture, thereby bringing the viewers the aesthetic experiences of varying delight as they visit these galleries. Gallery Street offers an overview of the diversified concerns and styles of Tsong's oeuvre, and provides three on-site experience modules:

(1) In the space of Gallery Street, the 3D sculptures and installations stand in a line to greet the visitors. In terms of size and scale, they present striking contrasts between giant and mini, towering and flat, as well as individual and cluster. In terms of medium and technique, they encompass the application and sublimation of basic metallurgy, carpentry, blacksmithing, and cement masonry. In terms of form and content, they display the evolution from pure artistic abstraction into installations that invite allegorical reading of society, culture, and politics.

(2) Along the wall of the exhibition space hung the graphic works differing in type and style, including minimalist-abstract paintings that appeal solely to vision, societal image works that rekindle collective memories, and mixed-media works that hybridize quotidian objects with graphic art.

(3) On the seven huge columns in the venue, the viewer can explore another version of Tsong's site-specific installation *Instant Bali* that owes its inspiration to yoga postures.

Generally speaking, the unique charm of Tsong's works is manifested in their layout in Gallery Street, i.e., "objects talk at the center with painted poem at both sides." The following explanations of the works will provide a deeper understanding of the multiple references of content and diverse

presentations of style.

Nomadic (1985) is a linear sculptural/spatial installation made of circular stainless steel bars. A single-shaped unit can be arranged in four different postures, and, in this way, it constitutes a grouped ground installation. Besides, dialogues with different spatial environments can be achieved by combining and extending more components when necessary. It's noteworthy that the lightness of the void in this work is a clever parallel to Richard Lin's sculptural installation *What's Ahead?* (1985) made of thick and heavy steel plates. The two approaches, one based on the void whilst the other on the solid, faithfully mirrored the two artists' distinct thoughts and practices in the field of sculptural installation.

Three Bamboo Joints (2022) is a penetrating linear 3D installation made of industrial angle steel. At first glance, it assumes a shape as free as abstract, but it is in fact a simultaneous optimization of the functional requirements of structural mechanics. The natural appeal lying in this work also reveals Tsong's intention to let this work "speak with more voices, spark fertile imagination, and be more amazing." If the viewers know that there is an order of insects whose members, generally called walkingsticks, mimic bamboo twigs, it will be easy for them to recognize that this loft-style work actually stages a drama of mimicry in which three walkingsticks pit themselves against one another.

May (1990) is one of Tsong's early tours de force on Taiwan's political phenomena. Its material usage and formal arrangement are as much simple and unadorned as metaphorically enthralling. In this work, the intersection of the two circles formed respectively by the steel poles and the mud balls suggests the interaction and conflict between the two forces that one is stronger than the other. The slightly loose cluster of colossal steel poles implies an edifice to be consolidated and strengthened, whereas the circle of small mud balls on the ground symbolizes a grassroots force under incubation. The technique of depicting things through objects indicates that, in addressing or responding to social issues, Tsong's works employ "sublime vocabulary with deep meanings without being stirring."

Of all Tsong's works over the years, *Laborers' Monument* (1990), which props up a large steel sheet with seven hoes, is the earliest to have the theme and name of "monument," and *Si Ba La Monument* (2008) that features a cube comprising 60,000 dices is the latest. In this solo exhibition, *1997 Monument* (1996) is a work Tsong created on site when he was invited to Hong Kong for the exhibition titled "Journey to the East 97: Installation Arts from Beijing, Shanghai, Taipei and Hong Kong" Using cement and mortar, the artist erected a monument and inscribed it for the historic year "1997" of global concern. The cement set a table and two chairs rigidly in place, symbolizing the relationships among China, Taiwan, and Hong Kong. Through the form and concept of "monument," Tsong injected the meaning of "epitaph" into this work without uttering a word.

Beckoning to a Myth (2013) comprises more than 20 triangular prisms as geometric as abstract. Combining various wooden doors and windows that evoke nostalgia, this work shows a settlement redolent of a former military dependents' village in Taiwan at the tail end of Gallery Street. The viewer may have a glimpse of the unique, vintage charm of each household from different directions and even from a bird's eye view, or move sideways through the narrow passages that demarcate and connect these households, so as to experience the lamentations that this place is deserted and the great cause of reclaiming the Mainland has become nothing but a historical myth. In a nutshell, this work portrays, in an atmosphere of solemn silence and a seemingly "decluttered" form, the fragmented elements waiting for a force to summon and regroup them into a whole.

B. Exhibition Area on the 1st Floor: Galleries 103-107

Galleries 103-107 are five indoor exhibition rooms on the first floor. Each has its own space while

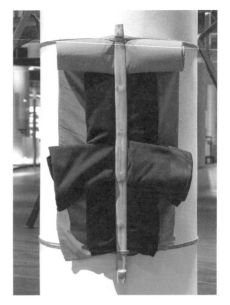

Figure 1

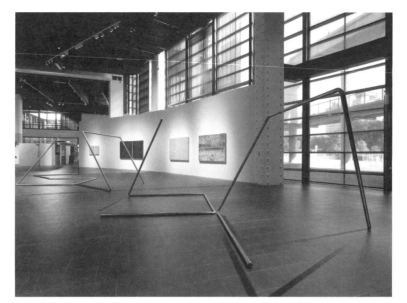

Figure 2

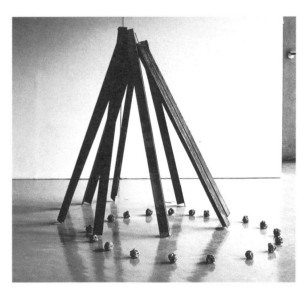

Figure 3

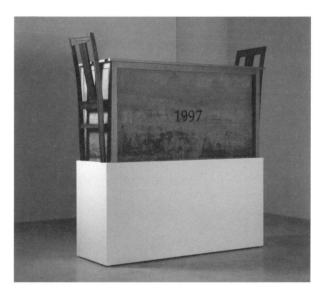

Figure 4

Figure 1 *Instant Bali*, 2023, shoulder pole, blanket, hemp rope and yoga mat, dimensions variable. Courtesy of the artist.

Figure 2 *Nomadic*, 1985, stainless steel, dimensions variable. Courtesy of the artist.

Figure 3 *May*, 1990, angle iron, pottery clay, dimensions variable. Courtesy of the artist.

Figure 4 *1997 Monument*, 1996, cement, chair, table and stand, 166×170×58 cm. Collection of National Taiwan Museum of Fine Arts.

being adjacent to the other. In this area, we select and arrange the exhibits in a way that allows the viewer, when following the traffic, to compare and appreciate the varying yet intriguing dialogues between the 2D "Tsong-style painted poem" and the 3D "Tsong-style objects talk." Broadly speaking, the "painted poem" is as much author-centered as art-centered in orientation, namely a self-extension of systemic painting, whereas the "objects talk" starts from daily life and resonates with the real world, as if each work was picked up at random and ruleless. The latter not only reflects methodical and formal diversity, but also attains inventive success in a non-systemic fashion. Obviously, the "painted poem" makes a continuous sprint on a self-determined path. By contrast, the "objects talk" comprises "off-road" creations that draw much of their inspiration from the everyday world. They frequently deviate from the track due to external inducements of all stripes, just like ancient literati who "found the defeat so poignant that petals are mingled with teardrops" and "lamented the separation so much that even birds' twittering sounds frightening."

The works selected and displayed in this area are described as follows in order of space and traffic.

(1) Gallery 103: The entire room is turned into a panoramic wall installation, a site-specific replica of Tsong's work *Escape the Scene* (1992). Based on our quotidian experience, it looks like a "scene of destruction" with a heap of debris on the ground and a faint odor of blood on the walls. Based on our artistic experience, however, this is actually a site of "history restoration," whereby the artist traces and analogizes the conscious behavior of prehistoric humans, such as leaving marks in caves with charcoal or blood. It also serves to remind us that "escaping the site of creation and writing a new chapter in history" was the very prologue to the development of civilization.

(2) Gallery 104: The minimalist installation *Colonnade* (2017) employs no other element than straight lines, rendering itself geometrically rational and purely abstract. Besides, the graphic series *Amphitheater of Hands* hung on the walls consists of 30 pieces completed successively by Tsong between 1999 and 2021. The artist deliberately juxtaposes the monochromatic seal-imprint paintings with black-and-white photographs of sign language. In sum, representational gestures, abstract paintings, and plastic installations all belong to "visual language." Yet, if the viewer cannot understand the implications of these gestures or sign language, the keynote of *Amphitheater of Hands* will point to a visual struggle between the dynamic rhythms of gestures and the static aesthetics of art, rather than a "discursive" debate about its content and theme.

(3) Gallery 105: The large-scale installation *In a Distant Snoring Sound* (2005) involves the following elements: five mutual-embedded wooden single beds, five long wooden posts, five black leather shoes, and five white pillows. These daily objects are familiar to the viewer. The sheer humor and its inflections, such as "sharing the same bed—but not the same pillow," "resting easy—without worries," and "ostensible partners with different agendas—resonating snore," may also be easier for the viewer to recognize and correlate. Nonetheless, there is a foretaste or a question; that is, a shoe is discovered missing on each post beside each bed. Did they set out on their respective journeys in a dream, or did they meet outside the dreamland?

(4) Gallery 106: The work *Worldly Scale* (2022) treats the self-retracting metal tape measures indispensable for artisans as the principal element in terms of structure and shape. Each group has 10 tape measures stretching lithely between two circular wooden boards respectively on the ceiling and the ground, which is reminiscent of a tall column as well as a playing fountain. The perfect balance between "strength and beauty" finds expression in the fascinating array of the 70 tape measures. Here, Tsong's "off-road" aura manifests itself in his act of "sublimating quotidian objects." Art is commonly regarded as light while tools dust. However, this work brilliantly demonstrates the captivating connotation of "effacing and blending oneself in with the secular world." It magnificently transmutes "practical tools" into "the noumenon of art." This work gives the viewer an impression that the artist abruptly shouted "cut" to stop the elapsing of materialized time and reproduced it to a certain spatial scale in the process of measuring the dimensions of this space. Therefore, the act of

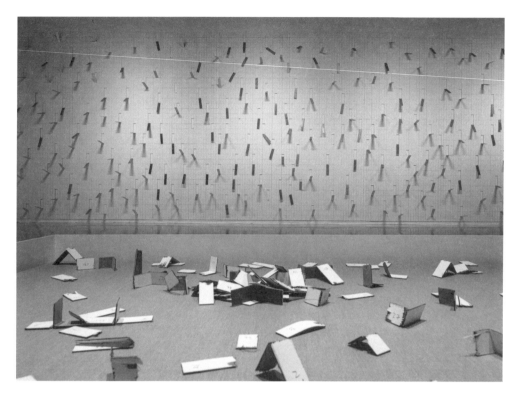

Figure 5 *Escape the Scene*, 1992, wood, dimensions variable. Courtesy of the artist.

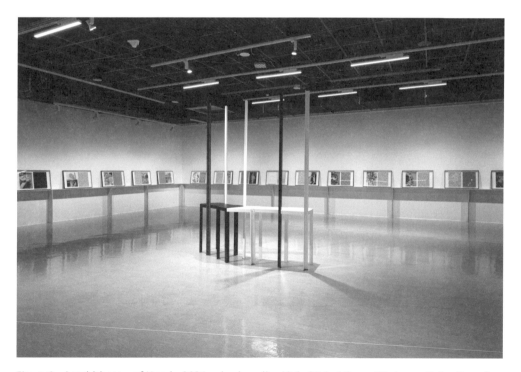

Figure 6 *Amphitheater of Hands*, 2021, mixed media, 49.6×84.1×3.6 cm, 30 pieces. Collection of National Taiwan Museum of Fine Arts.

"measuring the dimensions of this space" assumes the dramatic posture of "artistic presentation."

By way of comparison, the series of square paintings of the same size on the walls of Gallery 106 appears not so much a direct transformation as an intentional, analog technique-based simulation of digital effects. Besides, these paintings are characterized by a combination of the absolute sense of minimalist aesthetics and the random sensibility of abstract expression. Such an approach of "achieving it both ways" openly challenges the intrinsic dualism of abstract paintings, such as cold/warm, sense/sensibility, and control/random. It can be deemed a new hybrid arrival created by Tsong beyond the realm of abstract art in an "off-road" manner.

(5) Gallery 107 showcases the "Xindian Boys" series, namely the works created between 2012 and 2016 by Tsong Pu, Chen Shun-Chu, Wu Dung-Lung, and Su Hui-Yu. The single-channel video titled *The Determination of Life: The Best Day Ever* on the right side uses a long take and two fixed-point scans to record the performance of the four artists who wander about the natural landscape and enjoy peer interactions in the refreshing mountain scenery of Wulai. This work is displayed in slow, silent images and a seamless loop that nicely evoke the poetic imagery of downshifting and LOHAS. Perhaps we may regard this work as a contemporary Taiwanese variation of distinguished events among ancient literati, such as "a semiannual ceremony of purification" or "a winding stream party." *Lost in Interstellar Space* is a synchronized three-channel ultra-wide video projection installed on the left side. The slow-motion black-and-white images are intended to mimic the tonality of vintage sci-fi films. This work employs the narrative of outer space to insinuate the absurdity and void of the human world. The content of this video has strong associations with the past event that Lee Tsai-Chien suffered political bullying for his abstract sculpture and the scene in which the beautiful home along the Xindian River became an alien environment due to the typhoon calamity. Accordingly, the groundless human-made disasters and natural calamities on our planet are undoubtedly the first things seen by "those who're lost in interstellar space" upon their arrival.

C. Exhibition Area on the 2nd Floor: Galleries 203-205

Complying with the spatial and traffic planning of Galleries 203-205, the selection and layout of the works are intended to create an art corridor that revolves around the "Tsong-style paintings."

Tsong adopted equal-sided color squares (1-cm²) as the constitutive elements of his early works. Dots or squares are originally neutral marks. Yet, as every work of Kusama Yayoi bears her signature of polka dots, Tsong has seized squares as his. By dint of the concept of stamping and his manual work, the artist managed to transmute the geometric squares originally without specific meanings into a series of mark-based paintings that the viewer knows who the creator is even though the inscription of the name is wanting. They are referred to in this exhibition as the "Tsong-style paintings." The correlation and division among the three exhibition rooms are as follows: Gallery 205 basically represents the evolution of the "Tsong-style paintings" over the course of time. Gallery 204 samples Tsong's thoughts and achievements that reflect his bold attempt to carry minimalist paintings to extremes. Gallery 203 faithfully presents his latest works as they are.

Gallery 205 contains a total of 16 works, including 14 paintings and 2 installations. Spanning half a century, these paintings may serve as a microcosm of Tsong's mental journey.

Tsong's earliest works *Untitled* (1977-1982) and *Five Stickers* (1978) are the drawings he made when he was pursuing advanced training in Spain, in which his dual-track approach was faintly discernible. *Untitled* suggests the track comprising the derivative works (here a photo of an overcoat) that treat realities as the point of departure. *Five Stickers* indicates the other track of pure abstract drawings that reveals his creative philosophy of repetitively drawing in numerous

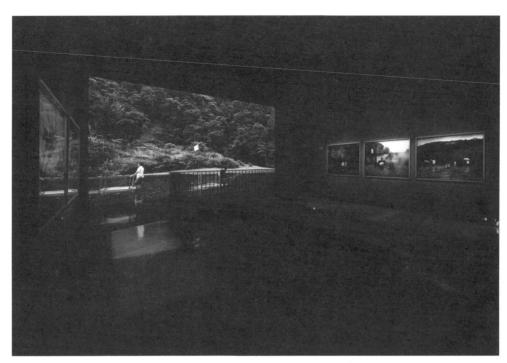
Figure 7

Figure 8

Figure 9

Figure 7 Xindian Boys (Chen Shun-Chu, Tsong Pu, Wu Dong-Lung, Su Hui-Yu), *The Determination of Life*, 2012, single-channel video, digital print and installation, dimensions variable. Collection of Taipei Fine Arts Museum.

Figure 8 *Untitled*, 1977-1982, sketch, 105×75 cm. Collection of Lee Daw-Ming.

Figure 9 *Dissipation Close-up*, 1982, oil paint on canvas, 190×130 cm. Private collection.

standardized small squares.

In *Dissipation Close-up* (1982), Tsong started to apply pigment in the form of brickworks. He confined himself to a monochromatic palette and single technique, consciously reducing his painting behavior into "a quantitative coloring game that allows for qualitative change." *Enticing Encounter II* (1985) is the work that epitomizes the consummation of this technique.

The series *Moonset, Sunrise* (1986) shows that Tsong began to chart new territories in the fields of sculpture, installation, and readymade by incorporating organic and open elements into the minimalist design of his works. *Hanging* (1989) is a comparatively simple work. It consists of imbricated paintings with twigs on their upper left edges. *True Love Never Disappear* (1993) is relatively complex. The artist divided and cut a movie poster into intricate grid squares, and then flipped the strips of different lengths inside out. In combination with random graffiti came the massive "white noise" that totally disrupts the discourse of the original image. With his craftsmanship and a touch of humor, Tsong directly unraveled and responded to the myth of love as the title of this work suggests. Similarly, the "off-road" aura sometimes radiates exactly from deciphering linguistic meanings. On the one hand, the work *Shinning Meet* (2008) cracks the "Tsong-style painted poem" because the depth of field in two-point perspective surprisingly appears out of thin air in the habitually flat compositions of Tsong's seal-imprint paintings. On the other hand, Tsong actually uses vertical and horizontal lines to create the illusion of intersecting "diagonal lines," foremost in the work *Spring Falls* (2020). Another underlying principle behind his creative philosophy is the insistence on "low-level" craft to resist the technological revolution of the digital age, in which all drawings and images can be reproduced with pixels (hence the disappearance of the aura of artworks).

Gallery 204 highlights Tsong's seal-imprint paintings that illustrate how he engages in diffusive exploration through horizontal thinking. For example, *Perceiving Cause* (1999) and *The Color of Frost* (1999) explore the ways of constructing awe-inspiring scenarios with a tremendous amount, just like the grains of sand in the Ganges or a canopy of stars. In addition, *Inside Coordinate (*2008) and *Spreaded Information* (2008) seek to create a visual jungle with a delightful blend of the dense and the sparse. Furthermore, *Invisible Layers of Scenery* (2014), *Jade Mountains and Pearl River* (2014) and *Ring* (2014) are about the exploration of "dynamics and amorphousness."

Finally, all the exhibits in Gallery 203 are Tsong's latest paintings completed in 2023. In this regard, his *Moonset, Sunrise* series (1986) seems to reiterate that "the past has gone like the moonset, and the present is coming like the sunrise." As far as Tsong is concerned, an artist shall bear the following saying in mind: "If you can improve yourself in a day, do so each day, so that you can build on improvement forever."

莊普 ── 物的臨場詩
總是「警戒姿態面對」的藝術

許遠達
國立臺南藝術大學藝術史學系助理教授兼臺灣藝術史暨檔案研究中心主任

1980 年代的前衛先行者

莊普，以「境」與「物」的「境派」藝術，與當時的前衛藝術家們，共同於臺灣 1980 年代提出解放傳統藝術框架的前衛藝術觀。在平面上提出知名的「一公分見方印記」，以自律性無關連的連續性蓋印，企圖呈現他所欲開創的「像是幾何形態的後抽象道路」。[1] 以「一」生無限的創作觀念，臨場生活，蓋印出了當代繪畫的另一條路徑。

在「境派」的藝術空間與材質解放的創作理念下，莊普以物質在空間中的實質存在進行裝置。他的裝置作品極具日常詩意，總能在極簡的物件裝置下，讓物件擴延意義與感受。

在藝術事件上，莊普也同樣是當時代極為重要的前衛開拓者之一，如：春之藝廊於 1980 年代初展出的「異度空間」(1984) 與「超度空間」(1985)；臺北市立美術館「前衛 · 裝置 · 空間」(1985)、「中國現代繪畫新展望」(1986)、「行為與空間」(1987)；SOCA 現代藝術工作室「環境 · 裝置 · 錄影」(1986)；臺灣省立美術館的「媒體 · 環境 · 裝置」(1988)；參與「伊通公園」(1988) 的成立等，可以說是無役不與。

莊普創作不拘於一格，面對藝術創作他以「警戒姿態面對」，不斷地重新地面對藝術創作的提問。因此，莊普的創作，無論是在極簡的「一公分見方」底下，或是空間的材質裝置，總是能變化萬千，跨越現在的莊普一再地另闢蹊徑，而有第一百零一個莊普。

以警戒姿態面對自己

莊普在西班牙就讀的是藝術創作觀念較為繪畫傳統的「馬德里大學聖費南度貴族藝術皇家學術院」。但從學院的人道精神與不時反觀檢視自身的觀念，卻貫穿了他的創作。他留學時的學院，畫作紀錄與批判戰爭的浪漫主義時期藝術家哥雅 (Francisco Goya, 1746-1828) 曾經是學院的院長，另外繪畫〈格爾尼卡〉(*Guernica*, 1937) 批判在弗朗西斯科 · 佛朗哥獨裁下的德國轟炸悲劇的畢卡索 (Pablo Picasso, 1881-1973) 及創作〈煮熟豆子的軟結構 —— 內戰的預感〉(*Soft Construction with Boiled Beans*, 1936) 的達利 (Salvador Dali, 1904-1989) 都曾是這所學校的學生，從這幾位藝術家身上，莊普感受到他們的人道主義精神。在學的期間，璜 · 卡洛斯 (Juan Carlos) 上臺，1970 年代中，左翼黨派街頭抗議不斷，1980 年代初的右翼政變。在充滿抗爭與革命氛圍中，莊普認知了藝術總是與政治牽扯，而需要有著人道主義的面對，不僅僅是形式的純藝術表現，而是從生活而來的當下感受，是以一種「警戒姿態面對」的藝術。

而正是這樣「警戒姿態面對」，因此莊普在藝術上總是路徑自闢，而總是越野超越。回國後的第一次個展的展名「心靈與材質的邂逅」(1983)，便透露了莊普以「警戒姿態面對」的創作狀態，「邂逅」強調了不帶意識形態、不預設立場與當下性。對於繪畫與裝置莊普指出：「繪畫的

1 引自誠品畫廊，莊普「幻覺的宇宙」展覽介紹，網址：https://reurl.cc/0Z190x，瀏覽日期：2023.10.02。

東西，比較純屬個人風格，出發點在於滿足個人的一些內在世界，呈現無法用文字或其他方式表達的東西。至於裝置藝術是現實的、需要讓人懂的，需要有人去看、去觸摸，達到觀看的互動效果。」[2] 心靈來自生活的思考與感受，莊普認為要在最簡單的形式中表達世界的豐富，因此，他將生活的變化萬千裝載在一公分見方的格子中。而一遇見物件，就遇見自然與社會，而莊普的創作總是當下、總是臨場，由某個模糊的心靈引導，在遇見材質的臨場以極簡成詩。

一公分見方裡的花花世界

關於繪畫，莊普首先面對的是現代主義的內在再現，他摒棄了筆刷避免透視，認為拿筆就會有模仿自然的再現問題。因此，「我的表達方式 —— 以一公分見方的印章代替了筆畫，章印出色彩和內容」[3] 所以他從自身的文化中找到了印章的形式，一種「我」的再現，一方面避免透視、空間的再現，回應極簡主義的藝術即物質與色彩本身，另一方面蓋印所形成對理性空間的擠壓，顏料溢出規矩，跨越直線而形成自由的邊界型態，是迥異於歐美的理性哲學，貼近了「變化即存在」的哲學觀。一公分見方就是一個方寸的世界，他以「一公分見方」的變化即存在，引發一公分見方的核爆，在畫面衍生無窮無盡的變化，呈現大自然的花花世界。

莊普喜歡牧谿、梁楷、八大山人、馬遠等藝術家的簡單幾筆的繪畫，他認為創作是：「找一個很簡單的道理、很簡單的形式或很簡單的材質，很簡單的空間，能夠表達豐富對生命、生活或對周遭的環境 …… 表達對藝術的感觸。」[4] 從少裡面見到豐富，是莊普創作極為重要的哲學。他曾經談及趙無極的繪畫觀念：「畫畫就是要經濟，要從簡單裡面要看到豐富，從少裡面要看到多，但不是表面多」[5]

所以莊普以極簡的「一公分見方」蓋印為基礎，蓋印色彩與大千世界。莊普的蓋印，並非企圖將世界收攏為純粹的極簡的存在，而是以不斷重複的蓋印方式生產差異，表現彩色萬千的萬千世界。也可以說如果印章在我們的文化中，是「我」的象徵，莊普蓋印的不僅僅是純粹特殊的「我」，而是普羅大眾的「我們」。

不同於林壽宇的「一即一切」的永恆性純粹的黑與白創作觀，莊普的創作則是道理存在於自然間與人世間生活的「變化是不變的道理」[6]。斜角一方面源自於至上主義的美學：「斜向四十五度的造型來自於馬列維奇至上主義裡，俄羅斯傳統宗教符號的方形、三角形與圓形」另一方面就

2 第 2 屆精銳藝術節，網址：https://lionjinray.com/aam2-2/，瀏覽日期：2023.10.02。

3 張晴文 編，《莊普：世界來自一個「有」—— 一個藝術家的五四三》，臺北市：臺北市立美術館，2010，頁 139。

4 引自「莊普簡單就是美 – 心靈與材質的邂逅」演講 (2:02-2:45)，網址：https://www.youtube.com/watch?v=WpXVuRqUjJY&ab_channel=NYCUOCW，瀏覽日期：2023.10.02。

5 引自「莊普簡單就是美 – 心靈與材質的邂逅」演講 (4:43-4:57)，網址：https://www.youtube.com/watch?v=WpXVuRqUjJY&ab_channel=NYCUOCW，瀏覽日期：2023.10.02。

性格而言，過度的理性與嚴肅，不是莊普的個性，他喜歡作品中帶有人的溫度。

因此，莊普也在他的正方形蓋印中再加上了斜角，四方形對稱的過度地靜肅方整不是莊普，他希望有點像是雨點那樣的皴法，有點霧氣的濕潤，有著斜線的動態韻律，而有了「斜角上遇馬遠－莊普個展」(2012)。另外，斜線所帶出的邊角的哲學，是莊普對於方形八方不動的嚴肅壓迫性的解危，馬一角式的大量留白閒適的觀看。

莊普一公分見方的重複蓋印，就是莊普所面對五色變幻的花花世界，有感的視覺詩。

現實之物‧臨場的詩

莊普總是以極為簡單的媒材、貼近零度的形式處理他的作品，以「警戒姿態面對」狀態，在每個當下面對媒材，創造臨場之詩。莊普說：「藝術家應該比平常人有能力，將生活上的東西，化做修辭、標點，使成為一首詩。」[7] 因此，莊普將生活的物件轉化為詩的修辭。簡單的材料，簡單的形式，莊普編排物件，不是文法結構完整的敘事，而在物件與物件的縫隙間，詩性飄渺地冉冉升起。作品〈有逗點句點的風景〉(2019)，莊普在真實的空間撒出標點符號，捕捉自然世界的現實的金黃之詩。

1984年的「異度空間」展莊普以〈七日之修〉(1984)以極簡的形式與物，將漆黑的夾板斜倚於繪畫的牆壁與立體的地面空間之間，解放了繪畫的框架與雕塑的臺座。作品走出了框架與臺座，極簡的形式使材質說話，材質成為實質空間中的存在。〈彩虹〉(1986)引進了自然的陽光時間變幻，光透過水分解成彩虹，是一首以自然為題的詩。極簡的材質在藝術家手中，成為了開拓前衛藝術的雄辯。

而逐漸地，莊普的媒材因為現成物的應用，不再限於極限純粹藝術的開拓，而有了文化與社會等關於生活的符號。〈曬日子〉(2017) 最適切地展示了莊普以最簡單的方式，從生活中提煉，令作品充滿詩性的物件的創作能力。鵝卵石沉重地拉扯著線，視覺的重也是時間的重，但莊普題名所展示面對的態度卻是輕盈的閒適。

另外，莊普的作品經常因為作品題名太過於生活真實，除了生活觀察的智慧外，還帶令人忍俊不住的輕鬆與幽默感。面對創作莊普說「我遊戲，因此我存在。」[8] 如〈我討厭村上隆 我討厭奈良美智〉(2008)是莊普對於策略式的創作型態的批評，他以臨時粗糙的木架，還有莊式一公分見方蓋印的占滿布袋，表現他的黑色幽默。另外，〈在遼闊的打呼聲中〉(2005)則是於金門的展覽與其他藝術家擠通鋪時此起彼落的打呼場景，非常貼近日常的場景幽默，莊普卻有鈴木大拙式的體悟，他聽著此起彼落不同聲量、頻率的打呼就像是夜間的另一種語言。從另一個角

6　　張晴文 編，《 莊普：世界來自一個「有」── 一個藝術家的五四三 》，臺北市：臺北市立美術館，2010，頁129。

7　　李維菁，〈 莊普：將「生活」化做修辭 〉，《 藝術家 》，No.320 (2002.01)，頁317。

8　　張晴文 編，《 莊普：世界來自一個「有」── 一個藝術家的五四三 》，臺北市：臺北市立美術館，2010，頁147。

度來看，如果打呼聲是莊普的一平方公分，那麼當晚的打呼聲在莊普的心裡就是一格格溢出而顏色互異的蓋印。

但莊普也有沉重的詩，〈五月〉(1990) 以歐洲的抗爭及社會運動都在五月，因此他藉沉重的黑色作為抗議現場視覺的感受，再以角鋼的灰黑及狀似骷顱頭的陶土象徵石塊及街頭抗爭的生命。另外，如針對「97香港回歸」議題所創作的作品〈1997 紀念碑〉(2020 年重製)，為藝術家中少見的政治題材之裝置作品，他以水泥呈現無可喚回被灌注一起的沉重。

就是因為莊普的創作總是以「警戒姿態面對」，因此，他的裝置作品並非計畫完整後的執行，大多都是當下性的，感受自己心靈與物質瞬間的相遇。他的裝置作品總是臨場才決定材質與形式，不讓慣性思考操縱，因此臨場成詩，與時代緊密結合，所以當代而能跨越荒野自闢蹊徑。

Tsong Pu — Improvised Object Poetry
An Art That Always "Takes an Alerted Stance"

Hsu Yuan-Ta

Assistant Professor and Director of Art Archive Center in Taiwan, Tainan National University of the Arts

An Avant-garde Pioneer in the 1980s

Tsong Pu and other avant-garde artists launched the "Jing-Pai" art focusing on the interrelations of "space" and "materiality," and collectively liberated traditional art and its conventional framework through the avant-garde concept in Taiwan in the 1980s. In terms of two-dimensional work, Tsong has created his signature approach using self-autonomous, unrelated, and continuous stamping of "a chop stamp measuring one square centimeter" to demonstrate "a post-abstract route in geometric form" that he has aimed to unveil.[1] Based on the artistic concept of "one" breeds the infinite, he experiences life in a spontaneous way, and utilizes chop stamps to unfurl an alternative approach to contemporary painting.

Through the artistic space formulated by "Jing-Pai" and the creative idea foregrounding the liberation of material, Tsong also creates installations based on the substantial existence of material in the physical space. His installations are informed by a strong sense of everyday poetic quality. He is always able to expand the meaning of objects and how they are perceived through minimalist installations of objects.

Tsong has also been a highly avant-garde pioneer in every crucial art events in the 1980s, for example, *Alien - Play of Space* and *Transcendent - Play of Space II* at Spring Gallery in the 1980s; *Avant-garde, Installation, Space* (1985), *Contemporary Art Trend in the R.O.C.* (1986), *Experimental Art-Action and Space* (1987) at Taipei Fine Arts Museum; the inaugural exhibition of the Studio of Contemporary Art (SOCA) – *Environment, Installation, and Video* (1986); *Media · Environment · Installation* at the Taiwan Museum of Art (now is the National Taiwan Museum of Fine Arts); and the establishment of the alternative art space, IT Park (1988). When it comes to artistic creation, Tsong has never confined himself to any specific framework or style. He has always taken "an alerted stance" in artistic creation to continuously re-consider and re-examine the questions encountered in art making. Consequently, Tsong's work, whether it is the minimalist painting created with "the one-square-centimeter stamp" or his spatial installation constructed with different material, has unveiled myriads of changes and allowed him to surpass himself in the present, blaze new trails, and reinvent his own practice.

Facing Oneself with an Alerted Stance

Tsong studied at San Fernando Fine Art Royal Academy (Real Academia de Bellas Artes de San Fernando) in Spain. In terms of artistic ideas, the art academy has leaned towards traditional painting. However, the humanitarian spirit permeating the institution and the idea of constant self-examination have thoroughly influenced Tsong's work. In addition, Romantic artist Francisco

* Translator's note: "Jing-Pai" (境派) refers to the connotation of works created by a group of Taiwanese avant-garde artists emerged in the 1980s. Their works are related to the sui generis (physical and/or abstract) space engendered by the works, or the external space where the works are situated, which also gives their works a site-specific quality. In Mandarin, "Jing" (境) can refer to both a natural and physical place as well as a religious and abstract space. The name "Jing-Pai" ("pai" meaning "school") thereby associates the works of this particular group of artists with not only the physical but also the metaphysical space. Hence, the use of the name "Jing-Pai" in this article instead a direct English translation.

1 Quotes taken from the exhibition introduction to *TSONG Pu: Illusions of the Universe* presented by Eslite Gallery. https://reurl.cc/0Z190x (viewed on 2023.10.02).

Goya (1746-1828), whose paintings recorded and criticized wars, was the dean of the academy, at which Tsong studied. Pablo Picasso (1881-1973), who painted *Guernica* (1937) that criticized the tragic bombing of the city by German army during the totalitarian reign of Francisco Franco, and Salvador Dali (1904-1989), who painted *Soft Construction with Boiled Beans* (1936), both studied in the same academy. From these artists, Tsong has perceived their humanitarian spirit. When Tsong was a student in Spain, Juan Carlos came into political power. In the mid-1970s, the left-wing party launched constant protests. In the early 1980s, the right wing precipitated a political coup. Immersed in the social atmosphere informed by protests and revolutions, Tsong became aware that art would always be entangled and have to deal with politics in a humanitarian manner rather than merely pursuing formal and pure artistic expression. One must begin with perceiving the present in everyday life—it should be an art that "takes an alerted stance."

It is precisely such an attitude of "taking an alerted stance" that has driven the artist to always seek his own path in art – a path that is always off-road and surpassing. The exhibition title of his first solo exhibition after returning to Taiwan – *A Meeting of Mind and Material*, already revealed Tsong's creative state informed by this "alerted stance." It was emphasized that this "meeting" carried no ideologies nor any pre-established position, but a sense of the present. Regarding painting and installation, Tsong states that "painting is more about the personal style. Its starting point is to satisfy the inner world of individuals, and present things inexpressible through writing or other forms. Installation art, on the other hand, is realistic and needs to be understood. It requires people to see and touch it in order to achieve the interactive effect of viewing." [2] The mind is enriched by the thinking and perception in everyday life. To the artist, it is imperative to express the abundance of the world using the simplest form. To achieve this goal, he contains the countless changes of life in the one-square-centimeter chop stamp. The meeting with an object signals a meeting with nature and society. Tsong's work is always about the present and the spontaneous— it is guided by a certain vague idea in mind, and is transformed into improvised poetry at the encounter of the material through a spontaneous approach.

A Varicolored World within a Chop Stamp Measuring One Square Centimeter

As regards to painting, the first topic that Tsong must deal with is the modernist representation of the inner world. He renounces the use of paint brush and avoids the perspective because he believes that the use of paint brush eventually leads to the imitation of nature and the problem of representation. Consequently, "my way of expression is to replace the paint brush with a chop stamp measuring one square centimeter to create the colors and contents with stamping." [3] On the other hand, stamping also debases the rational space since the paint tends to ooze out the straight edges, forming boundaries in a free, organic form. This differs utterly from the Western philosophy emphasizing on rationality, but instead approximates the philosophical concept that posits "change is existence." A one-square-centimeter stamp represents a world in itself—utilizing the changing existence visualized by the one-square-centimeter stamp, the artist creates an explosive world

2 The 2ⁿᵈ Jinray Art Festival. See https://lionjinray.com/aam2-2/ (viewed on 2023.10.02).

3 Chang, Ching-Wen, editor. *Tsong Pu: The World Comes from a 'Being' - Something About an Artist*. Taipei City: Taipei Fine Arts Museum, 2010, p. 139.

4 The quote is taken from the talk – "Tsong Pu: Simplicity is Beauty—Meeting of Mind and Material" (2:02-2:45).See https://www.youtube.com/watch?v=WpXVuRqUjJY&ab_channel=NYCUOCW (viewed on 2023.10.02).

that brings about endless changes in the image, portraying the infinitely different world of nature.

Tsong has always been fond of Muqi (牧谿), Liang Kai (梁楷), Bada Shanren (八大山人), and Ma Yuan (馬遠), whose works are known for their simple style of composition in respective way. To Tsong, artistic creation means to "find a very simple principle, form, material, or space that is capable of expressing abundance, life, living, the surroundings…or one's feelings towards art." [4] To show abundance using less has been a crucial idea to Tsong's art. He quotes the painting concept of Chao Wu-Chi (趙無極), stating that "painting should be economical. It should be able to show abundance in simplicity, to show less in more, instead of just showing a lot on the surface." [5]

So, he builds upon the foundation of the minimalist "one-square-centimeter chop stamp," creating an array of colors and a boundless universe through stamping. Using the method of stamping, the artist does not aim to contain the vast world in a purely minimalist existence. Instead, the variations produced by repeatedly stamping enable Tsong to express the varicolored and bountiful world. In other words, if a chop in our culture is a symbol of "I," the stamping made by Tsong does not denote the pure and unique "I" but the "we" that refers to the general public.

Dissimilar from the idea of "one is everything" upheld by Richard Lin (林壽宇), which is embodied by the artist's permanently and purely black-and-white works, Tsong's work honors an idea that underlies nature and life in the mundane world — "changing is the never-changing principle." [6] The diagonal lines appearing in Tsong's work, on the one hand, points to the aesthetics of Suprematism: "the form created by the 45-degree diagonal lines has its origin from the square, triangular and circular in traditional Russian religion in Malevich's Suprematism." Character-wise, Tsong also prefers to mix a touch of humanity in his work rather than being overly rational and serious.

So, Tsong adds diagonal lines into his works of the square stamp pattern because the extremely rigid, orderly symmetry formed by squares does not resonate with his own personality. He wants the stamping to look like the wrinkling strokes that create the effect of raindrops, which is slightly misty and moist, with a sense of dynamic rhythm engendered by the diagonal lines. This endeavor gave birth to "Ma Yuan at a Corner : 2012 Tsong Pu Solo Exhibition". Furthermore, the corner philosophy put forward by the diagonal lines beckons at Tsong's solution to the serious, oppressive feeling created by squares, which echoes the extensive blankness and the sense of leisure from viewing Ma Yuan's painting. Tsong's repeated stamping of one-square-centimeter chop stamp forms his visual poetry inspired by his perception of the varicolored, changing world of boundlessness.

Realistic Objects · Improvised Poetry

Tsong has always utilized extremely simple material and handled his work in ways approaching degree zero. In the state of taking "an alerted stance," he perceives the material in the very present to create his improvised poetry. According to Tsong, "an artist, comparing to ordinary people,

5 The quote is taken from the talk – "Tsong Pu: Simplicity is Beauty—Meeting of Mind and Material" (4:43-4:57). See https://www.youtube.com/watch?v=WpXVuRqUjJY&ab_|channel=NYCUOCW (viewed on 2023.10.02).

6 Chang, Ching-Wen (editor). *Tsong Pu: The World Comes from a 'Being' - Something About an Artist*. Taipei City: Taipei Fine Arts Museum, 2010, p. 129.

7 Lee, Wei-Jing. "Tsong Pu: Transforming 'Life' into Rhetoric." *Artist*, no. 320 (2002.01), p. 317.

should be more capable of transforming things in life into rhetoric and punctuation to compose a poem."[7] So, Tsong converts objects in everyday life into the rhetoric of poetry. His material is simple, so is the form he uses. The way he arranges objects is not to compose narratives that are structurally complete, but rather to evoke the elusive sense of poetry from between the interstices between different objects. In *Scenery with Commas and Periods*, Tsong scatters punctuation marks in the physical space as a way to capture the golden poetry in the natural world.

His *Seven Days of Practice* exhibited in "Alien – Play of Space" of 1984 is also constituted of a minimalist form and objects: the installation reveals several black plywood boards placed in a way that they simultaneously lean against a wall for mounting two-dimensional painting and are placed on the floor in the space for showcasing three-dimensional works, liberating the framework of painting and the plinth of sculpture. Freed from framework and plinth, the minimalist form of the work allows the material to speak and have a presence in the physical space. *Rainbow* makes use of natural sunlight and the change of time. Through water, light is refracted and dispersed into prismatic, rainbow-like rays, making the work a poem themed on nature. In the hands of the artist, the minimalist material expands the avant-garde art with eloquence.

Little by little, because of his use of readymade, Tsong's media are no longer confined to the expansion of minimalist and pure art. Instead, he begins incorporating signs from everyday life that are related to culture and society. *Days Airing Under the Sun* is the most appropriate example, which demonstrates the artist's ability of using the simplest way to refine objects into a poetically charge work, in which the pebble stones pull down the strings in a weighty manner. The visual heaviness speaks also of the weight of time. However, Tsong gives this work a title that shows the carefree lightness in his attitude.

Additionally, because the titles of Tsong's works are often down-to-earth and realistic, they also exude a sense of amusement and humor apart from his insightful observations of everyday life. Regarding artistic creation, Tsong asserts that "I play, therefore I am."[8] For instance, *I Hate Takashi Murakami, I Hate Yoshitomo Nara* is Tsong's strategic criticism that is creatively formulated. He uses coarse, makeshift wood stands and two canvas bags covered in his signature pattern of one-square-centimeter square stamps to express his black humor. Moreover, *In a Distant Snoring Sound* is inspired by the scene of incessant snoring when sharing a room with other artists overnight in Kinmen and preparing for an exhibition. The humorous scene based on quotidian life somehow shows a realization reminiscent of D.T. Suzuki's philosophy. As he listens to different artists' snoring of varying volume and frequency, the snoring becomes an alternative language during the night. From a different perspective, if snoring were Tsong's one-square-centimeter stamp, the snoring from that night had created the grid stamping in different colors in the artist's mind.

However, Tsong also creates works that give off a gloomy, heavy feeling. *May* stems from the fact that the outbreak of protests and social movements in Europe is usually in May. So, he utilizes hefty black color to convey the visual perception of the protesting scenes, and uses angle steel bars in dark gray as well as skull-like pottery clay as symbols for rocks and the lives involving in street demonstrations. *1997 Monument* (remade in 2020) is a work addresses the "handover of Hong Kong in 1997," which is a rare installation engaging in a political topic among the artist's works. In this work, Tsong uses cement to express the weight of being irrevocably bound together.

Throughout his career, Tsong has always "taken an alerted stance" in artistic creation. Therefore, his installations are scarcely projects carried out with thorough planning. Instead, they mostly result from the instantaneous "meeting" between the artist's mind and the material in the now.

8 Chang, Ching-Wen (editor). *Tsong Pu: The World Comes from a 'Being' - Something About an Artist*. Taipei City: Taipei Fine Arts Museum, 2010, p. 147.

The material and form of his installations are always decided onsite in a spontaneous manner to avoid the pitfall of inertial thinking. Thus, Tsong's improvised poetry has been closely entwined with the times, which makes it contemporary and is able to forge a different, off-road path through untrodden territory.

藝術的洞穴之喻

口述｜莊普

整理｜朱文海

處於穴居的原始人類思維方式並不是和我們一樣的，是依賴於從技術而來的線性推理，或是進一步的去「建構」他們意圖的安身之所。原始人類所面臨的所有問題，幾乎都是屬於面臨生存與消亡的現實性問題，所以他們自然而然的也不會去使用推理判斷的角度，而是本能性的去採取最直接有效的方式，從這個角度上看來，原始人類為了居住而去挖鑿洞穴，正是為了生存而採取的破壞本能。莊普從創造學的角度，進一步的詮釋了藝術起源與洞穴產生的雷同，他認為：人類對於破壞的行為，其實是源於一種創造性的心理需求。耶穌的身體在十字架上被劃一刀，以及封塔納畫布上的那一刀、洞窟壁畫的牛血顏料，以及立體派分割畫面、達達主義或是超現實主義 …… 我們可以發現，人類從生存本能上開始的破壞，其實同時也已經具備了創造或是重組另外一端價值，這種能力的經典表現便是存在於純粹的藝術世界裡。莊普以洞穴作為藝術思考的起點，將我們引入了一個認識方式上的回溯，而被人類學家列維 - 布留爾 (Levy-Bruhl, Lucien) 稱之為原始思維的特徵，一旦我們懂了原始思維的原邏輯，而後才有可能不會被那種長期以來早已習慣的現代邏輯所束縛，而這種本於人性自然姿態反應，正是莊普在這一段期間受到巴塔耶 (Georges Bataille) 在《愛神之淚》一書中，啟發了關於藝術的起源與破壞的原生關係，他所談到的破壞並不是單純地為了獲取一種形式上的革新所採取的造型顛覆，而是更為原生性的回溯到人類的認識行為本身具有的多重創造性，最終也不會是將創造性置於一種現代主義以來的可控性當中。

因此，當巴塔耶提出了將「情慾」作為一種衝破自我的力量，自然能夠強烈的吸引莊普去思考藝術產生的方式，所以當他以「破壞」的概念作為起點時，便是很清楚這是一種結合了文化學與人類學脈絡的藝術思考，而這樣的思考將在我們品評任何認知判斷時，會不由而然地沾染上作為人類勝過於其他生物所驕傲的倫理位階。在巴塔耶所描繪的洞穴裡，這種人類特有的倫理位階，會妨礙我們以最原始的慾望去面對自身的情慾，他所說的情欲恐怕要比我們認知的更為原始，並且超越了宗教道德，而能夠直觀於人類對於情欲可能衝破現實的路徑。由這一層面看來，這種欲望和人類欲求從藝術創作中摸索突破並打開現實的路徑可謂殊途同歸，他舉例了我們可以由一種無神的宗教經驗，也就是情色經驗中的人類基本慾望，達到如同宗教中諸如神話、信念、儀式的神聖概念，並將這些概念連結成為我們內在的神聖性。巴塔耶將這種內在的神聖性和宗教慶典的原始精神連結，而構成了一個由情慾而生的創造力。

釐清了藝術（創作）活動的時間脈絡，是處於像是宗教般的神聖境況下，如此才能理解「情欲」並不是簡單的肉慾衝動，而是被依附於像是面臨聖境下可能期待的聖喻，莊普十分認同「慾望」的狂暴力量，以及它的耗竭或是耗損性質，其本性和我們在藝術創作時的狀態或是處境相似（這也正是莊普認為藝術是一種由破壞中而來的更新辯證）。所以從這個角度看來，這與我們長久以來所接觸的古典美學中所強調，那種本於整體性（古典美學）而訴諸的反覆、漸變、對稱、均衡、調和、對比、比例、韻律 …… 抽象性質不同，「情欲」的美學性質必須是聯繫於肉身，如同巴塔耶所認為：肉體本身有其自身限制，以及面對死亡的現實問題。因此莊普選擇了「洞穴」作為藝術的中介，正如巴塔耶以「情欲」作為人文創造的中介，實質上是準確的掌握了藝術作為體現人文表現至為關鍵的要點。在此方面，莊普表示洞穴象徵著死亡，所面臨的正是肉身面對著死亡的時間問題。如果人類沒有不斷面臨死亡的時間投射，那麼將很可能不會產生其一生的自我投射設定，這是一個哲學上的經典問題，但是所涉及於死亡的慾望或是破壞的概念，卻也在創作當中形成了像是洞穴般的神秘驅力影響著我們在創作上的迫切性。

洞穴作為藝術的開端

洞穴作為一個複雜神祕的符號，對於人類來說具有多種意義。洞穴在最原始的情況裡，大多是經由自然造就出來的，因此呈現出千變萬化，爾後有了動物進入居住，便成為了牠們繁衍安居的家園。當然，這其中也包含了人類，並且由於人類特有的想像力，使得我們總是盼望能夠從那種伴隨人類千萬年的洞穴遺跡中，尋得一絲有關自身的蛛絲馬跡。那麼，是甚麼樣的存在使得洞穴擁有那樣豐富的，在它的符號性質中承載著，並且是以藝術的姿態出現？這個問題是莊普以藝術創作作品回答，並且將這個具有始原性質的提問，置於這一次展覽中作為標題，希望能夠在一種題註中，引領觀者閱覽這一次展覽的其它所有作品。

莊普的「洞穴」裝置作品中，延續著自己在現代主義時期慣用的複數均質表現手法，但是卻迥異以往在畫布上以鉛筆打格子，而是採用墨斗蘸上動物血液繪製。此部分，同樣是受到了巴塔耶在《愛神之淚》一書中，所描繪的那一場景：一頭腹部內臟外露的野牛，身旁躺著一具挺露下身的獵人屍體。莊普從洞窟以及宗教繪畫中，見到許多動物死亡的畫面，並且由當中領悟出某些藝術真理，此件裝置作品以墨斗繪製為起點，企圖以一種傳統的儀式去還原洞穴的神祕內涵，莊普以往徒手打格子是憑藉著身體去書寫，此次所運用的墨斗在古代以來經常是被用於建築構件過程的定置基礎，在這個基礎以前其實是有祭祀的行為，因此當創作者以墨斗蘸取動物血液替代了徒手繪製，事實上就已經將整個藝術行為引領到了某種儀式性當中。莊普的這一番操作正如上文所示：真正的藝術表現在於溢出自我意識，而將此刻帶入了像是一種宗教或是慶典的時間。而他所運用的動物的血液更是將此神祕性聯繫於一種亙古以來萬物更迭的始源性，儘管殘酷但卻是真實的呈顯宇宙的生滅是帶有愛慾與殺戮的殘酷世界，因而對比了人類在擁有自己的社會制度以後，更多的將藝術的真理綁縛於理性的整體性，卻反而遺忘了存在於洞穴當中那些難以爬梳的真理。

莊普認為近來的這一段期間，對於自己的創作比較有一種歷史性的宏觀整體思考，儘管以往的作品是以理性為主的創作，但是若將它置於某種歷史脈絡下，似乎顯得主觀封閉。而在巴塔耶的思想中，讓他重新觸及並反省自城邦社會以來，人類脫離了穴居生活以後的思考變化，轉而關注「洞穴」文明能夠在當代藝術中喚起甚麼樣的可能。事實上，藝術家本人也清楚，洞穴作為當今考古的對象，它的存在無法以印證的方式呈顯我們的預設，但是卻可以作為一個遺跡的文本對象，提供當前在人文思考上所觸及的困境，並做為文本能夠觸及的想像，因此它總是神祕的、創造性的以及富有啟示性。在莊普的「洞穴」裝置作品裡，他以自己最具代表性的方格子（墨斗蘸獸血）鋪滿了一道牆，並象徵著人類挖掘洞穴的方式破壞完整的白牆面，這個進入藝術脈絡的破壞過程中，藝術家進入將物質材料轉換成為精神內涵的召喚遊戲。當然，他也尋思著洞穴作為人類文明遺跡，對於我們可能產生的想像方式，並不如同博物館裡的文物是經由年代考證，但是卻更為鮮活地指向一種富有題旨的解釋性。就如同自己創作的這一件洞穴裝置作品，其中並沒有任何視覺圖像上的故事性，而只有一些象徵性的符號和形式，其在藝術創作過程中的觀念性，並且強調每一種解構的思維都將產生不同的創造。

The Allegory of the Cave in Art

Dictated by Tsong Pu

Compiled by Chu Wen-Hai

Primitive men living in caves had a different way of thinking. The relied on linear deduction from techniques, or further "constructed" their intended homes. The problems faced by primitive men were mostly real issues of life and death, so naturally, they did not look at things from a deductive and judgmental perspective; instead, they intuitively adopted the most direct and effective methods. From this perspective, primitive men's digging of caves for shelter was the destructive nature for survival. From a creatological perspective, Tsong Pu further interprets the similarity between the origins of art and the birth of caves. He believes: the destructive behaviors of men are really originated from a creative mental need. The cut on the body of Jesus on the cross, Fontana's cut on canvas, the ox blood of cave paintings, and segmentation of Cubism, Dadaism or Surrealism..., we can see that, the destruction carried out by mankind from their survival instinct really also has the opposite value of creation or reassembly, and the classic expression of this ability exists in the pure world of fine arts. Tsong Pu uses cave as the starting point of artistic thinking, guiding us to a retrospective on the ways of knowing. As for the unique characteristic referred to as original thinking by anthropologist Lucien Levy-Bruhl, only when we understand the original logics of original thinking can we then be free from the shackles of modern logics we have long grown accustomed to. This natural reaction originated from human nature is Tsong's concept of the native relationship between the origins and destruction of art inspired by Georges Bataille's *The Tears of Eros (Les larmes d'Eros)*. The destruction he talks about is not a graphic subversion launched simply to attain formal reform, but to more natively revisit the multiple creativity of mankind's behavior of knowing; ultimately, he will not be placing creativity within a kind of controllability of Modernism.

Thus, when Bataille proposes to regard "lusts" as a force for breakthrough from self, he naturally offers a powerful trigger for Tsong Pu to consider the ways of art production. Thus, when he uses the concept of "destruction" as the starting point, he clearly understands that this is an artistic thinking that incorporates the contexts of culturology and anthropology. This kind of thinking, when we critique any cognitive judgment, will inevitably take on the moral hierarchy prided by men as the superior being above all other creatures. In the cave depicted by Bataille, this moral hierarchy unique to men prevents us from facing own lusts with the most primitive desires. The lusts he refers to are perhaps even more primitive than in our understanding; it transcends religious morality and directly shines light on the path of the possible breakthrough from reality of men's lusts. In this aspect, this kind of desires and the path of men's desire to explore, break through, and open up reality through artistic creation are really two different means to the same end. He presents an example: men can achieve the same sacred concepts of religion, such as myth, belief, and ritual, through a kind of atheist religious experience, that is, men's basic desires in exotic experience, and connect these concepts into our inner sacredness. Bataille connects this inner sacredness with the original spirit of religious festivals, building a creativity born from lusts.

Only by clarifying that the temporal context of art (creation) is in a sacred situation like religion can we understand that "lusts" are not simply physical impulses, but are attached to the sacred edicts one may anticipate when facing a sacred situation. Tsong Pu highly agrees with the violent power of "desire," as well as its exhausting or damaging quality; its nature is similar to our state or situation when engaged in artistic creation (this is also an updated argument supporting Tsong's belief that art is born from destruction). From this perspective, this differs from the abstract qualities emphasized by classical aesthetics we have long been exposed to, such as repetition, graduation, symmetry, balance, harmony, contrast, proportion, and rhythm..., based on integrity (classical aesthetics); the aesthetic quality of "desire" must be associated with the body, just as Bataille believes: the physical body has its own limits, as well as the real problem of facing death. Thus, Tsong chooses "cave" as artistic medium, just like Bataille's use of "lusts" as the medium of cultural creation. In fact, he has a precise grasp on the crucial key of art as the manifestation of cultural expressions. Regarding this, Tsong expresses that cave symbolizes death, and the issue it faces is the very issue of time faced by the body in the face of death. If men did not have the temporal projection of constantly facing death, it would be highly likely that their life setting of self-projection would not be created. This is a classical question in philosophy, but the concepts

of desire and destruction of death it touches on form a mysterious driving force like cave in the creative process, fueling our creative desperation.

Cave as the Beginning of Art

As a complicated mysterious symbol, cave has multiple meanings to men. In the most primitive situation, most caves were naturally formed, and thus they came in a wide range of forms; later, animals moved in, and caves became their habitats for reproduction. Of course, the animals also included men. Moreover, with men's unique ability of imagination, we always look forward to finding some kind of clues relating to ourselves in cave monuments that have accompanied mankind millions of years. Then, exactly what kind of existence caves have in abundance and carries in its symbolic quality, and appears as art? Tsong answers this question with his creative works, and uses this question of origin in this exhibition as a title, hoping to provide a footnote that guides visitors to view other works at the exhibition.

In his "cave" installation, Tsong carries on his plural and homogenous expressive method during the Modernist period; in the past, he used pencil to draw grids on canvas, but this time he uses an ink line with animal blood to draw grids. This is also inspired by a scene described by Bataille in *The Tear of Eros*: A bison with its entrails spilled lying with the corpse of a hunter with an erected penis. In caves and religious paintings, Tsong has seen many scenes depicting death of animals, from which he realizes certain truth about art. This installation begins with grids drawn with an ink line, and attempts to restore the mysterious quality of caves through a traditional ritual. When drawing grids free-hand, Tsong relies on his body for writing; the ink line he uses this time had often been used in ancient times to set the foundation during construction. In the past, people held worshipping rituals for laying the foundation, and therefore, when the artist replaces free-hand drawing with an ink line with animal blood, he has in fact drawn the entire artistic action into a certain rituality. This operation of Tsong is just like what was mentioned above: real artistic expression lies in spilling own consciousness, taking this moment into a religious or festive time. The animal blood he uses further ties this mystery with the primitivity of the eternal cycle of life; though cruel, it truthfully presents that the births and deaths in the universe are a cruel world with love and killing. It is therefore a contrast to how men ties the truth of art with rational integrity after establishing own social systems, yet they forget the truths existing in caves that are difficult to comb through.

Tsong thinks that he has recently done some macroscopic considerations on the historicity of his creative works; although his past works are mainly based on rationality, when they are placed in a certain historical context, they seem subjective and shut-off. Bataille's thinking allows him to again touch and reflect on the changes in mankind's thinking since leaving behind caves and establishing city-state society, and turn his attention onto the possibilities that may be conjured by the "cave" civilization in contemporary art. In fact, the artist himself is clear that, as a subject of archaeological excavation today, cave's existence presents our default in a way that cannot be proved, but can serve as the textual object of a historic site, offering an imagination on the current dilemma of cultural thinking that can also be touched on by the text. Thus, it is always mysterious, creative, and richly revelatory. In the "cave" installation, he covers an entire wall with his signature grids (ink line with animal blood), and destroys the intact white wall to symbolize men's digging of caves. In this process of destruction that has entered an artistic context, the artist enters a conjuring game of converting material substances into spiritual contents. Of course, he also ponders on the possible ways of imagination that may be generated by caves as historic sites of human civilization; unlike relics in museum that are researched and dated, they more vividly point to an interpretive-ness with rich topics. Just like this cave installation created by himself, there is no visual and pictorial narrative, but only symbolic symbols and forms. His conceptuality in the creative process and his emphasis on every kind of deconstructive thinking will give rise to different creations.

作品圖版
Plates

月落・日出 *Moonset, Sunrise*, 1986

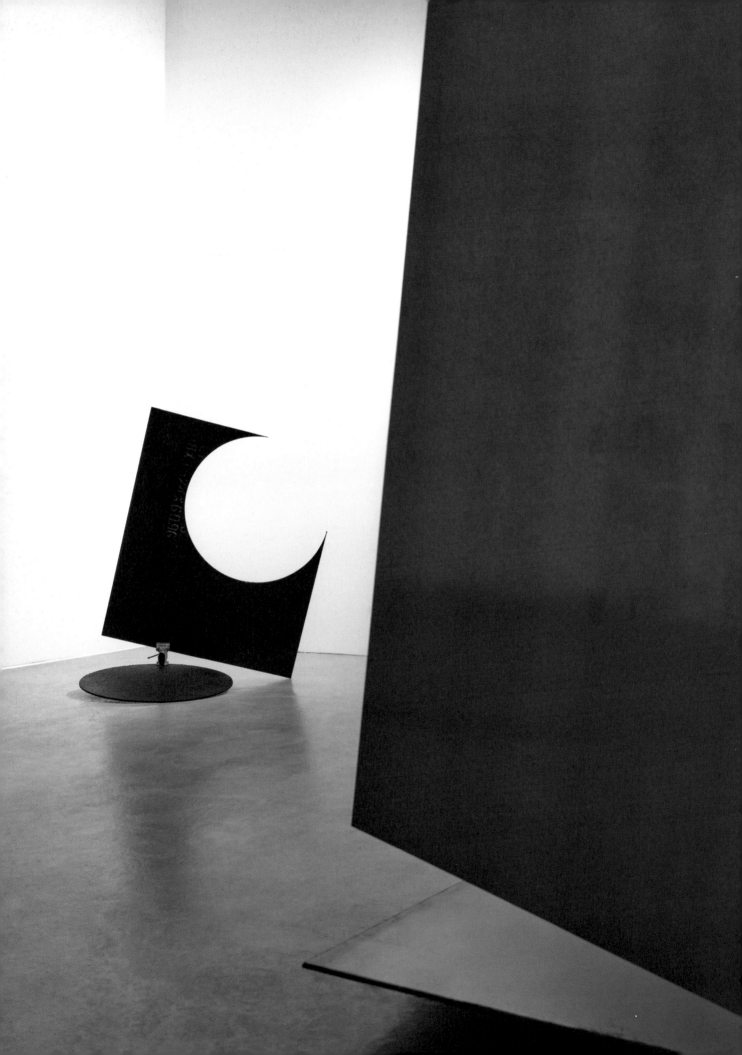

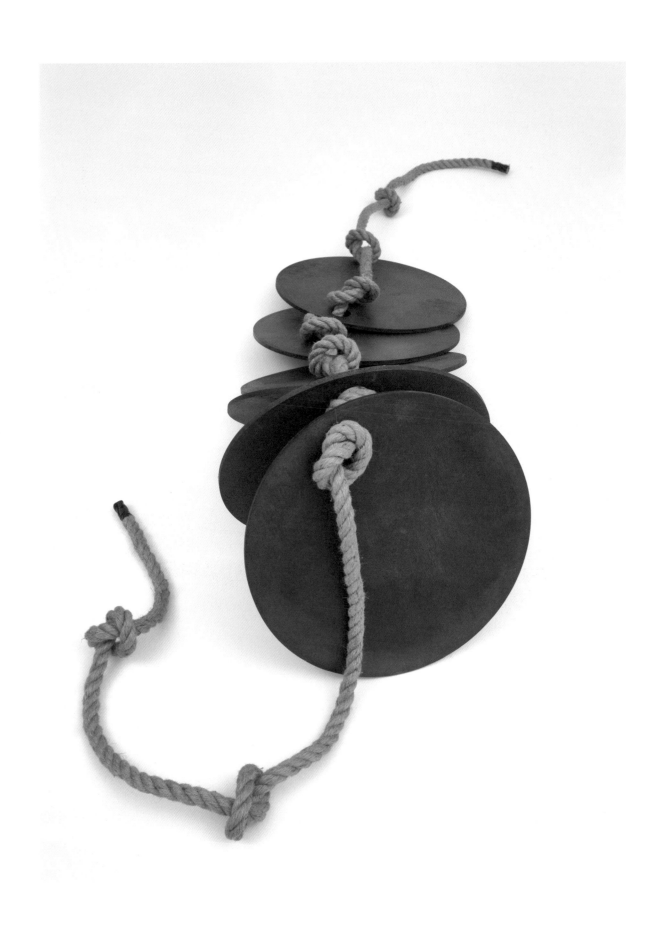

一串月圓 *A String of Full Moons,* 1986

日出 · 日落 *Sunrise, Sunset*, 1986

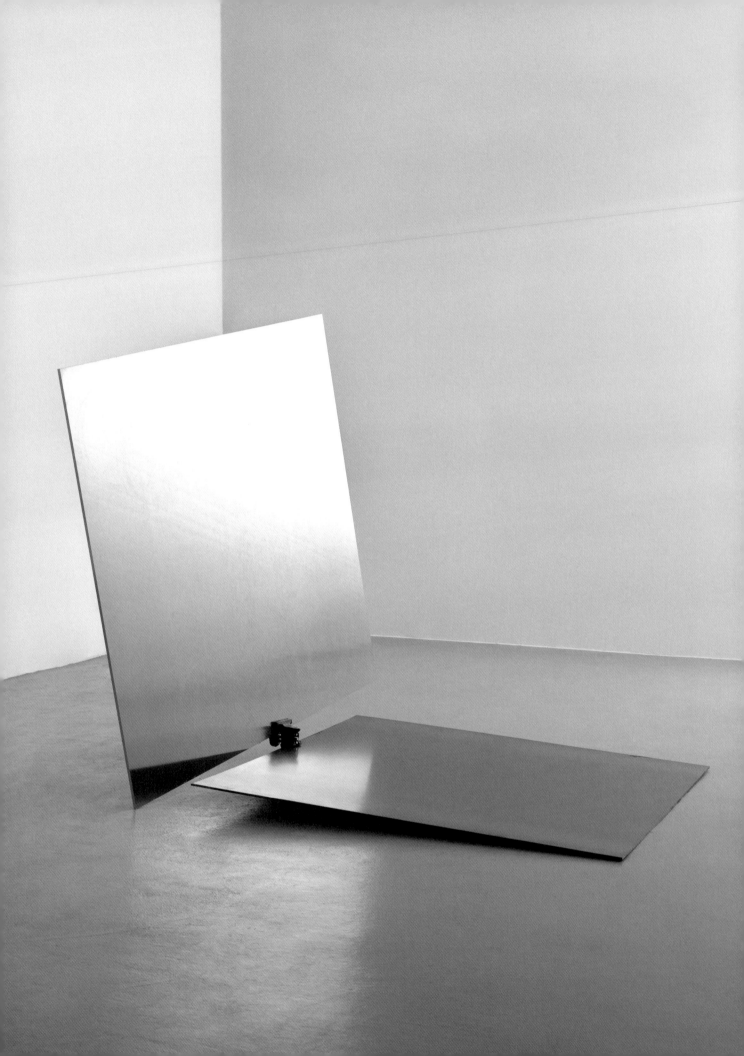

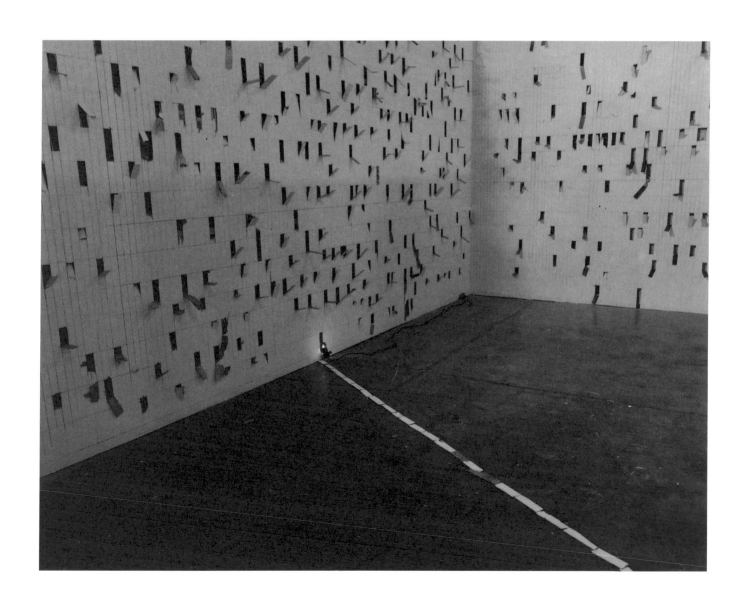

逃離現場 *Escape the Scene,* 1992

真愛不滅 *True Love Never Disappear*, 1993

紅線 *Connection*, 2022

無題 *Untitled*, 1977-82

五張貼紙 *Five Stickers*, 1978　　　69

靈韻 *Spiritual Rhythm*, 2022

遠方的眼淚 *Faraway Tears,* 2022

黑色逗點的轉移　*Transition of a Black Comma,* 2022　　73

象限 *Quadrant*, 2020

烧 *Light of the Fire*, 2019

鳴泉飛瀑 *Spring Falls,* 2020

　看不見的風景層 *Invisible Layers of Scenery,* 2014

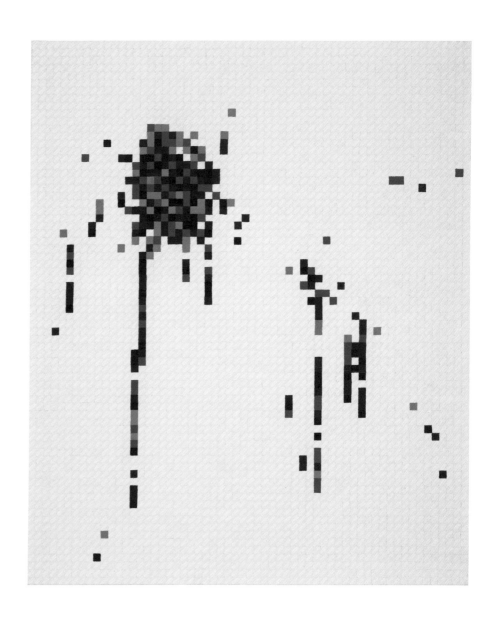

生日 *Birthday*, 2022

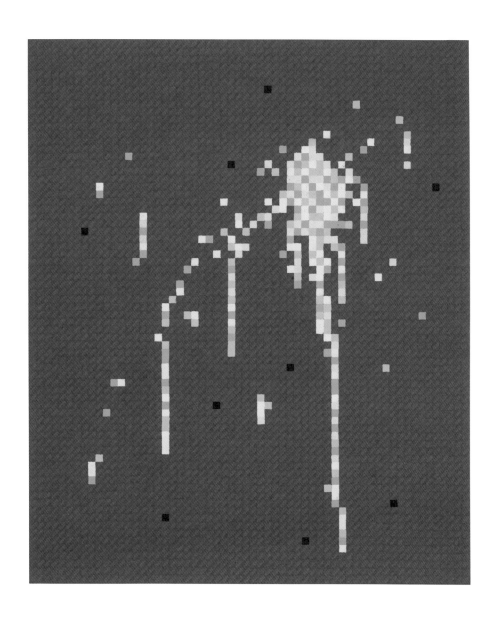

水仙花 *Daffodils*, 2022

夜暖嫩綠草叢間的五段變化 *Five Stages of Change Among the Green Grass of a Warm Evening, 2023*

日出之前 *Before Sunrise*, 2017 89

天目 *Tenmoku*, 2019

丹靈 *Sun*, 2019

藍星 *Blue Star*, 2020

共生之星 *Symbiotic Star*, 2020

港都太陽 *Seaport Sun*, 2017

遠方的鄉愁 *Nostalgia from Afar,* 2017

把喜悅的光送往各處 *Sending the Light of Joy Everywhere*, 2023

鳴 *Ring,* 2014　　99

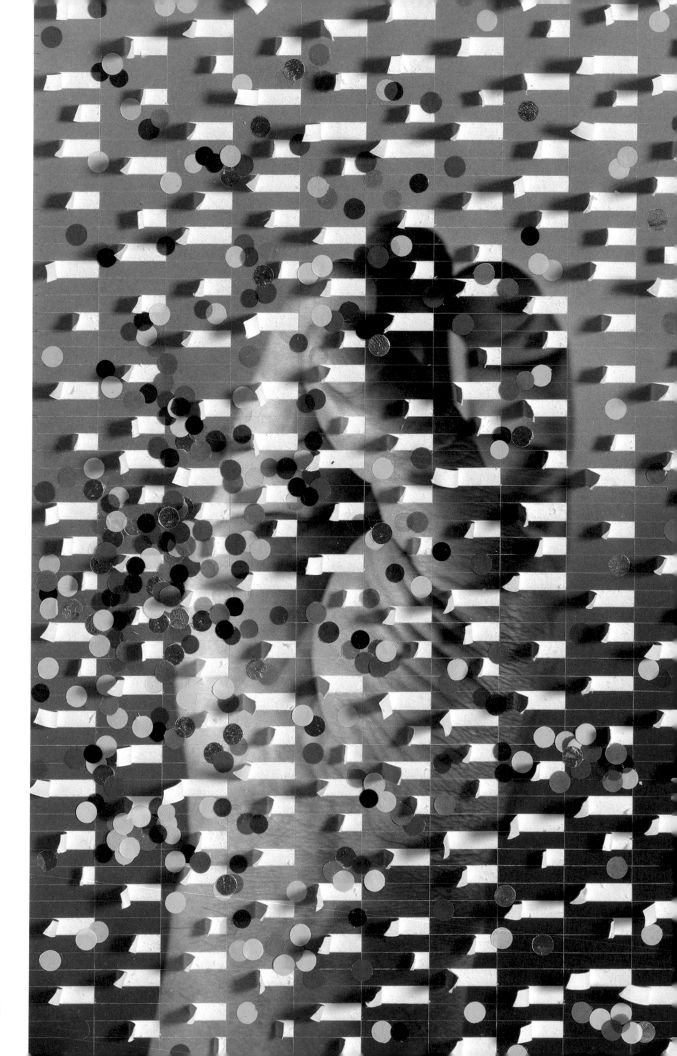

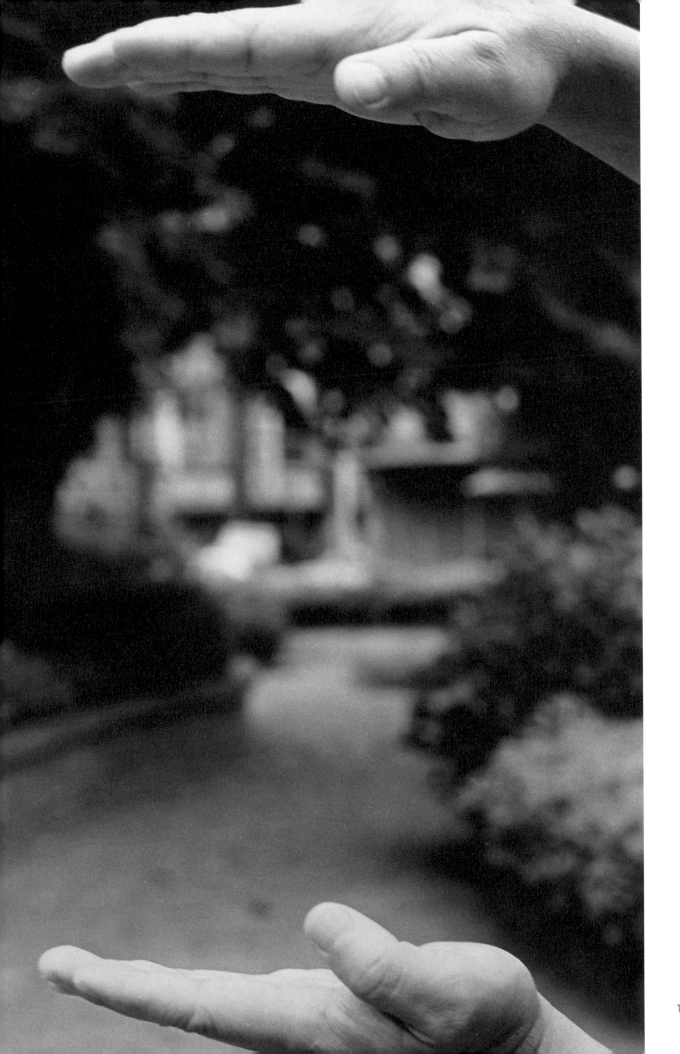

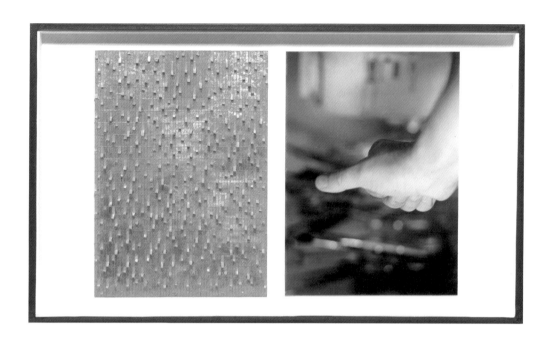

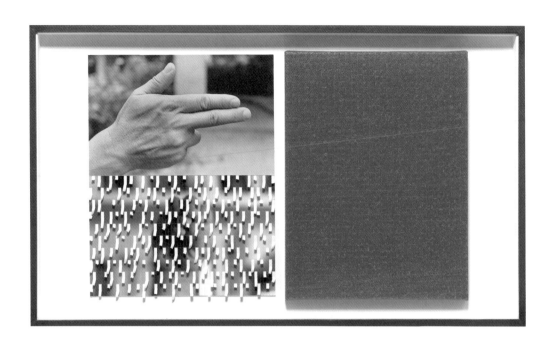

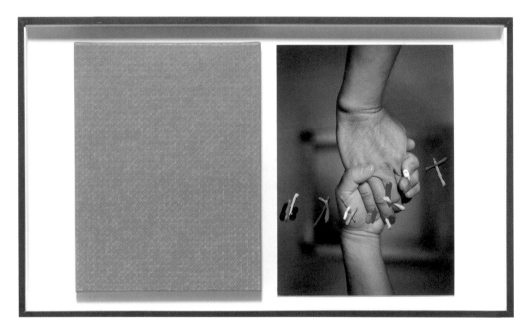

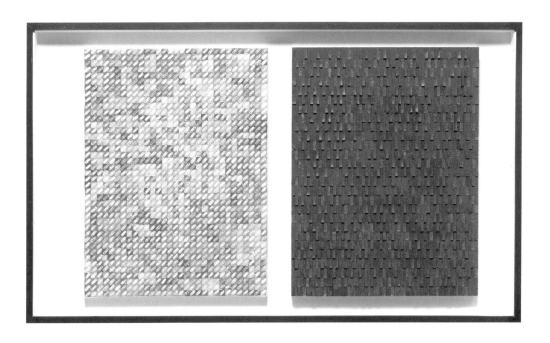

手的競技場 *Amphitheater of Hands,* 2021

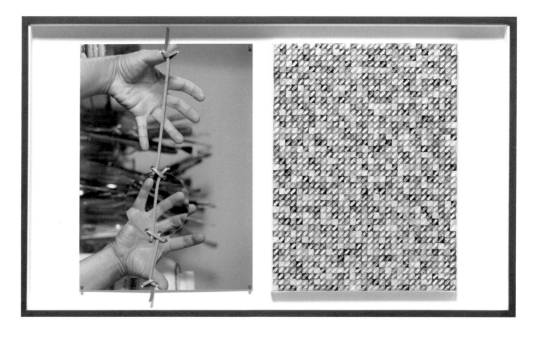

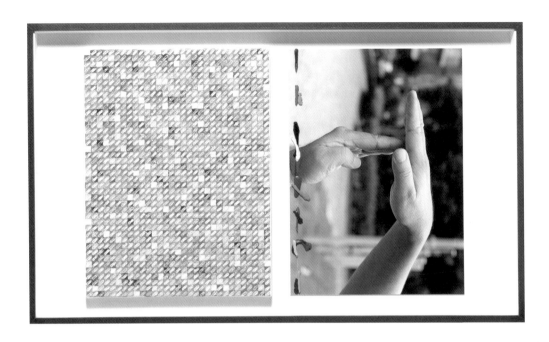

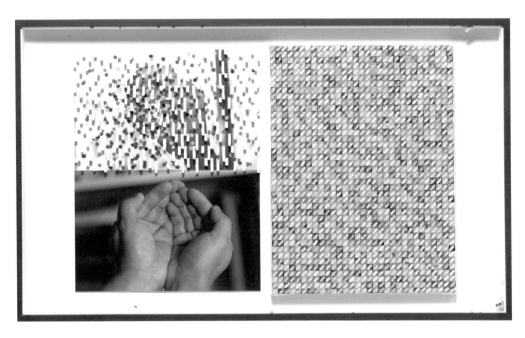

手的競技場 *Amphitheater of Hands,* 2021

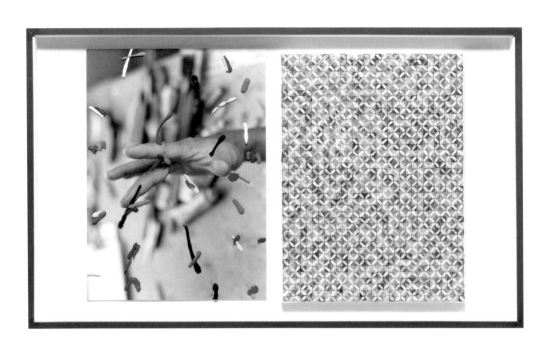

手的競技場 *Amphitheater of Hands*, 2021

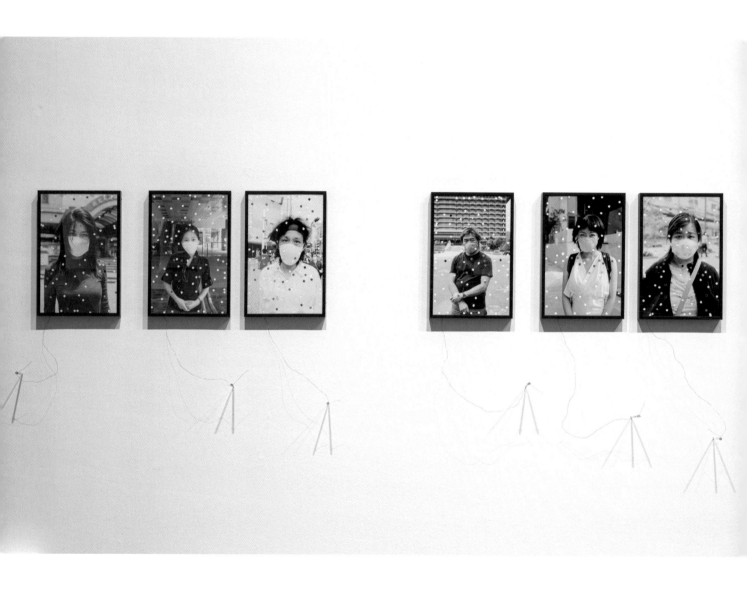

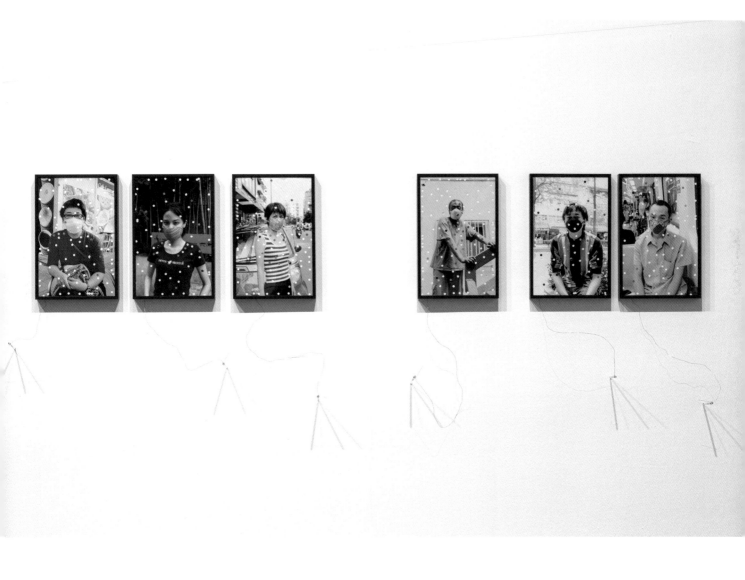

一目了然 821 *At a Glance* 821, 2019

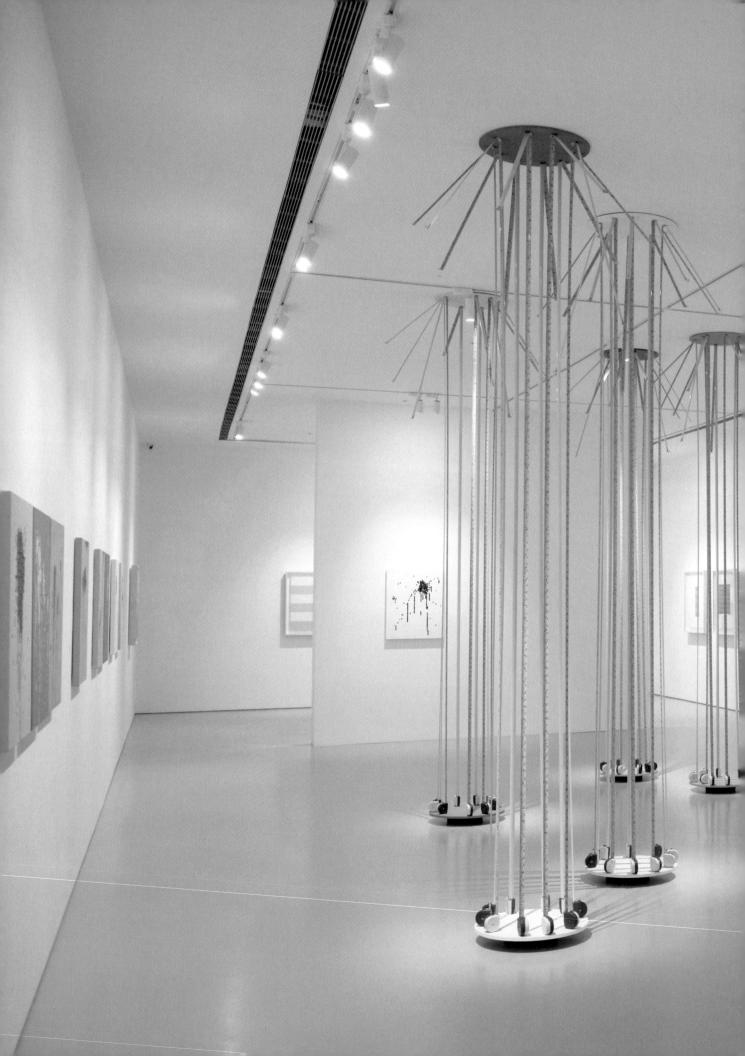

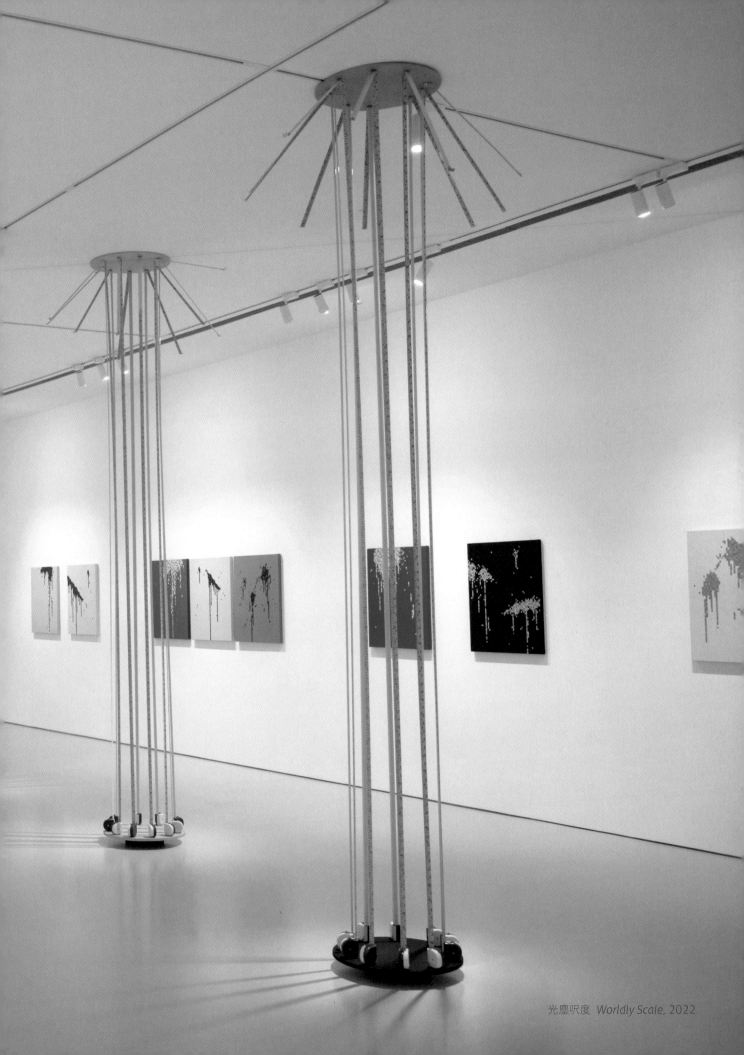

光塵呎度 *Worldly Scale*, 2022

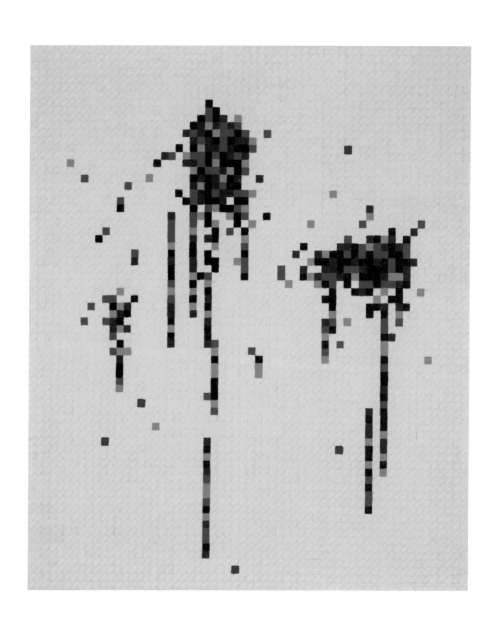

　　　　　　　　　　　　　　　　　　　　　藍色的消遣 *The Dissolution of Blue,* 2022

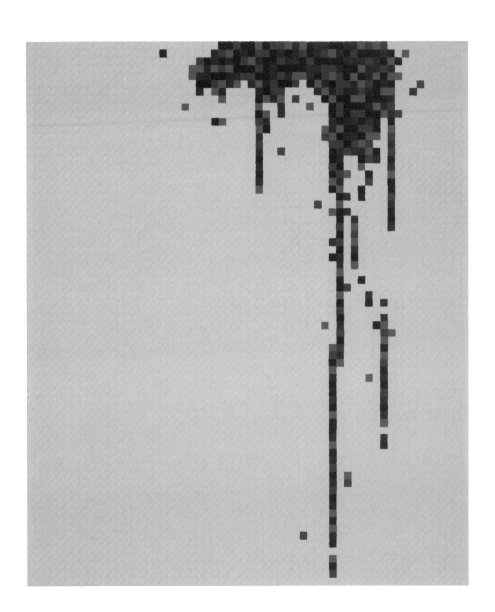

方的方法 *The Way of the Square*, 2022

 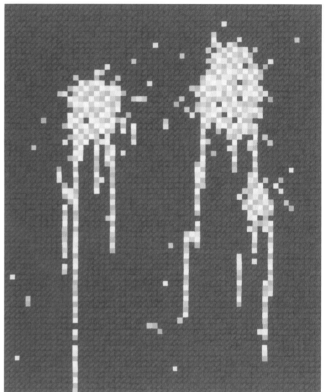

環形的邊緣 *Annular Fringe,* 2022 停泊 *Anchoring,* 2022

沙丘 *Sand Dunes,* 2022 紫雨 *Purple Rain,* 2022 123

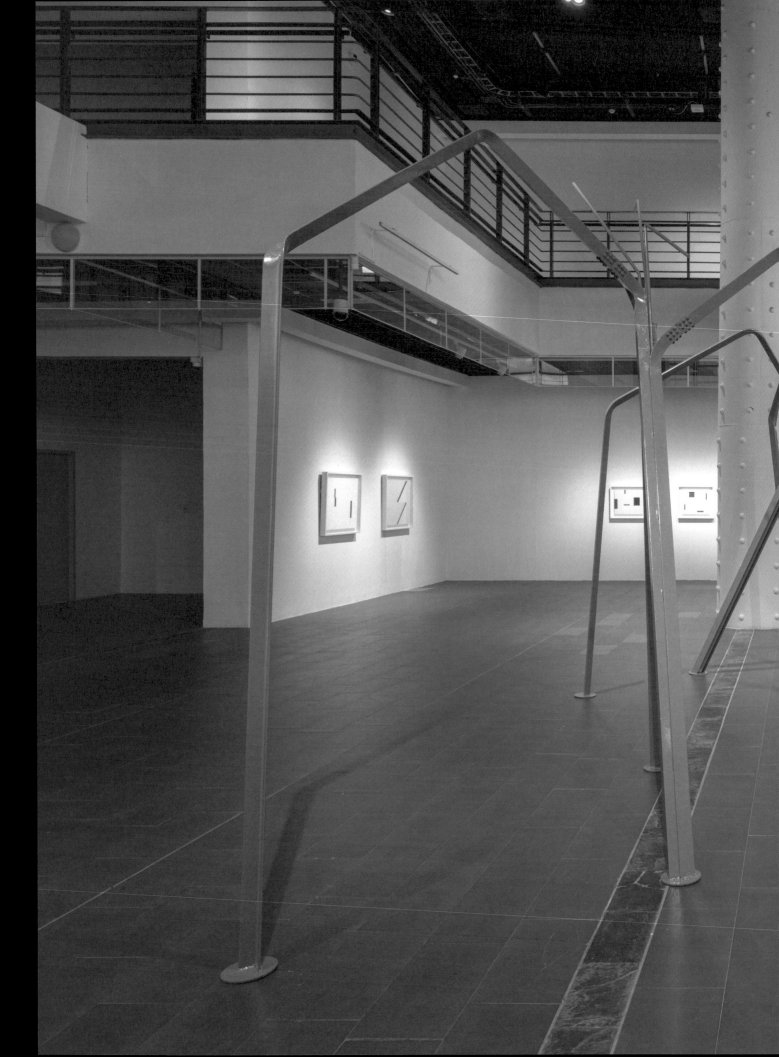

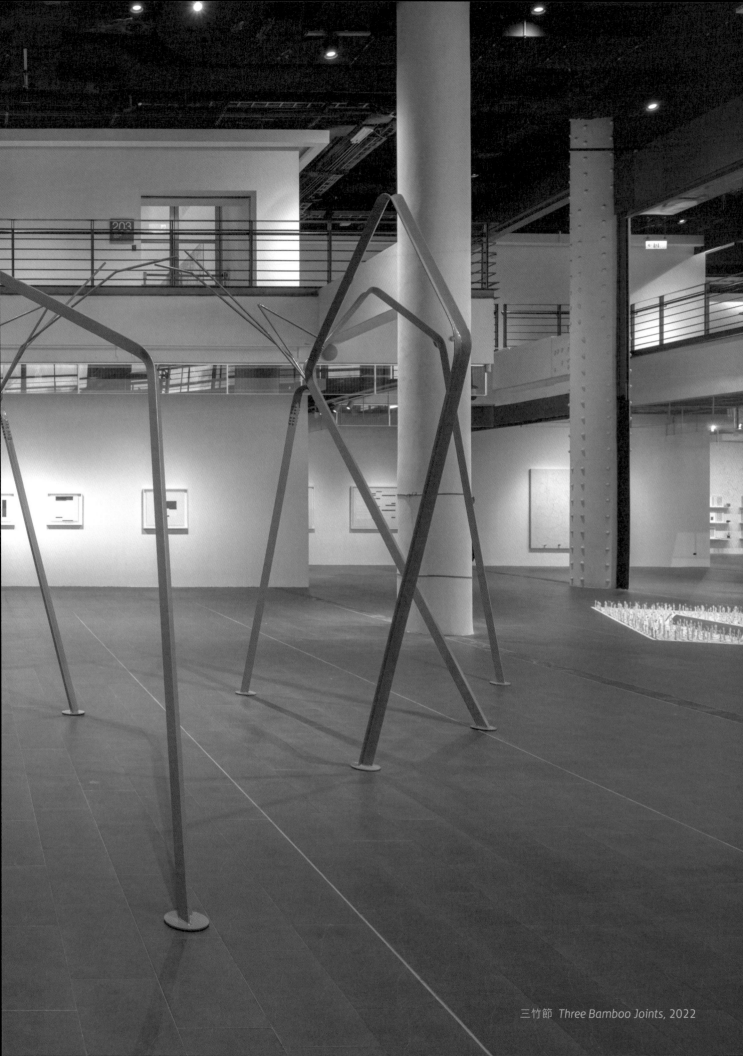

三竹節 *Three Bamboo Joints*, 2022

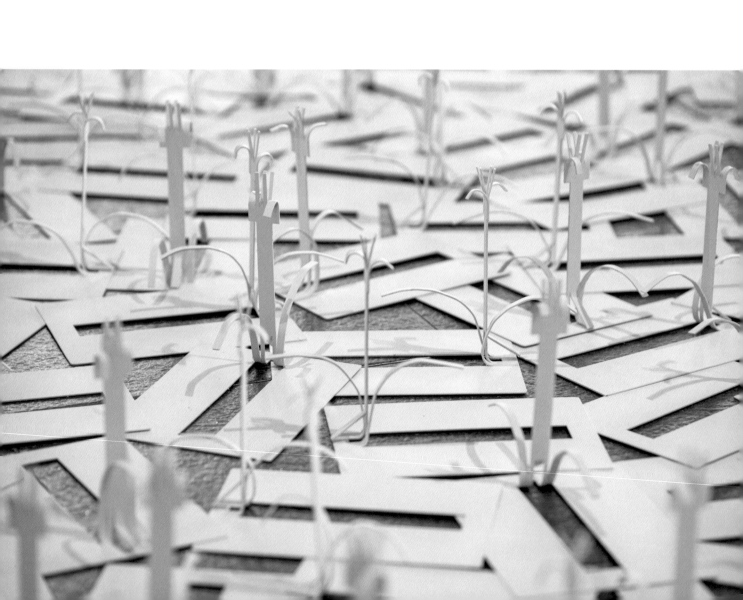

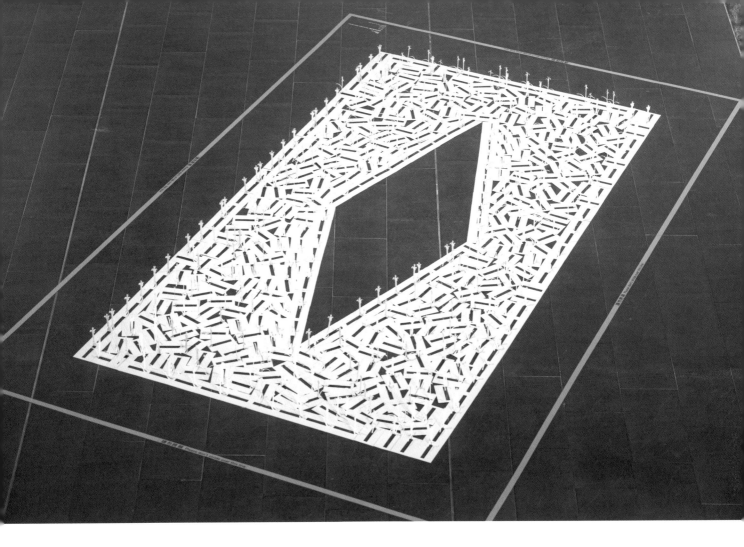

迷走的白色花園 *Wandering in White Garden,* 2010

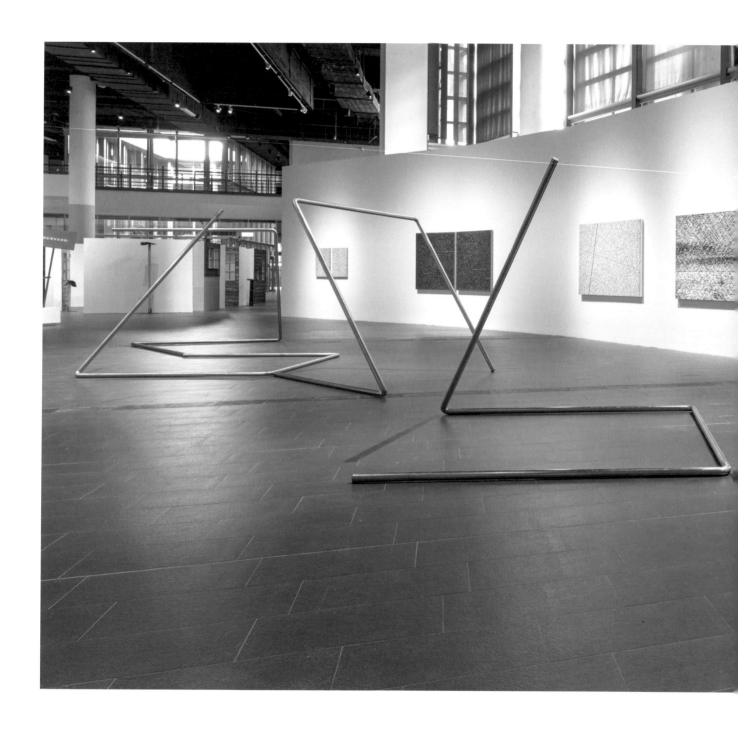

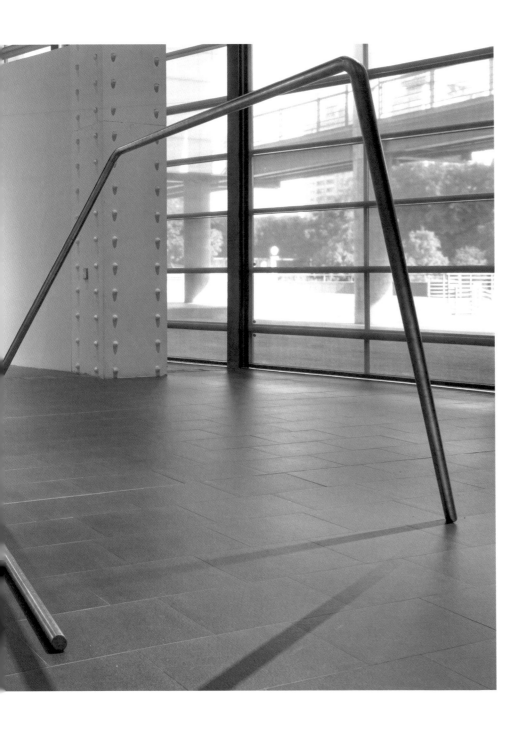

來去自如遨遊四方 *Nomadic*, 1985　　　　129

越過黃白間的弧線 *Crossing the Arc Between White and Yellow, 2021*

白色蝴蝶 *White Butterfly,* 2021

你就是那美麗的花朵 *You are the Beautiful Flower,* 1997　　133

很多的目標和一個目標之一 *Many Goals and One* -1, 2023

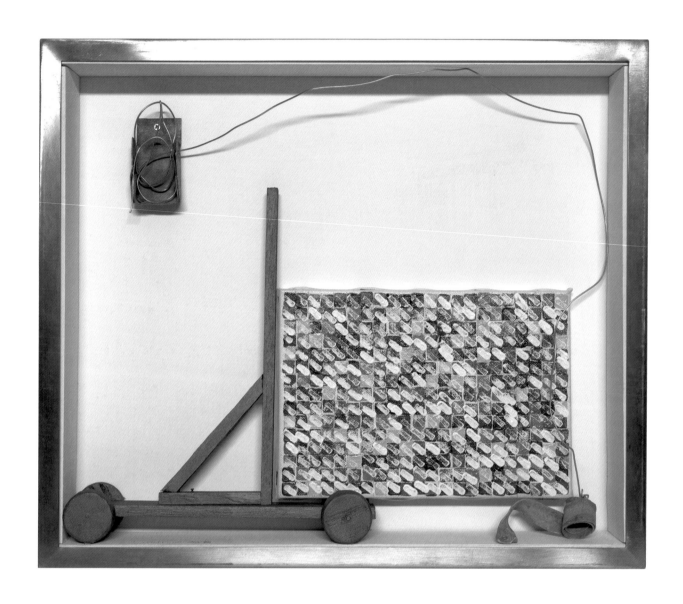

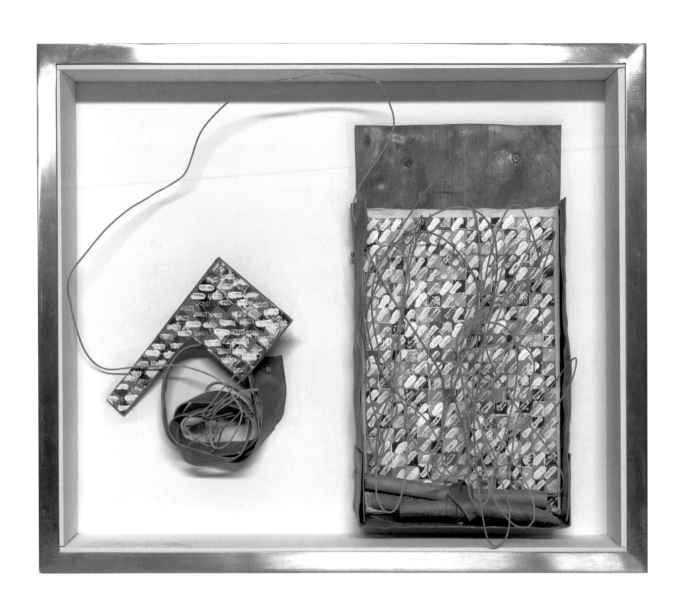

蠻荒原質 *Primal Wilderness*, 1991

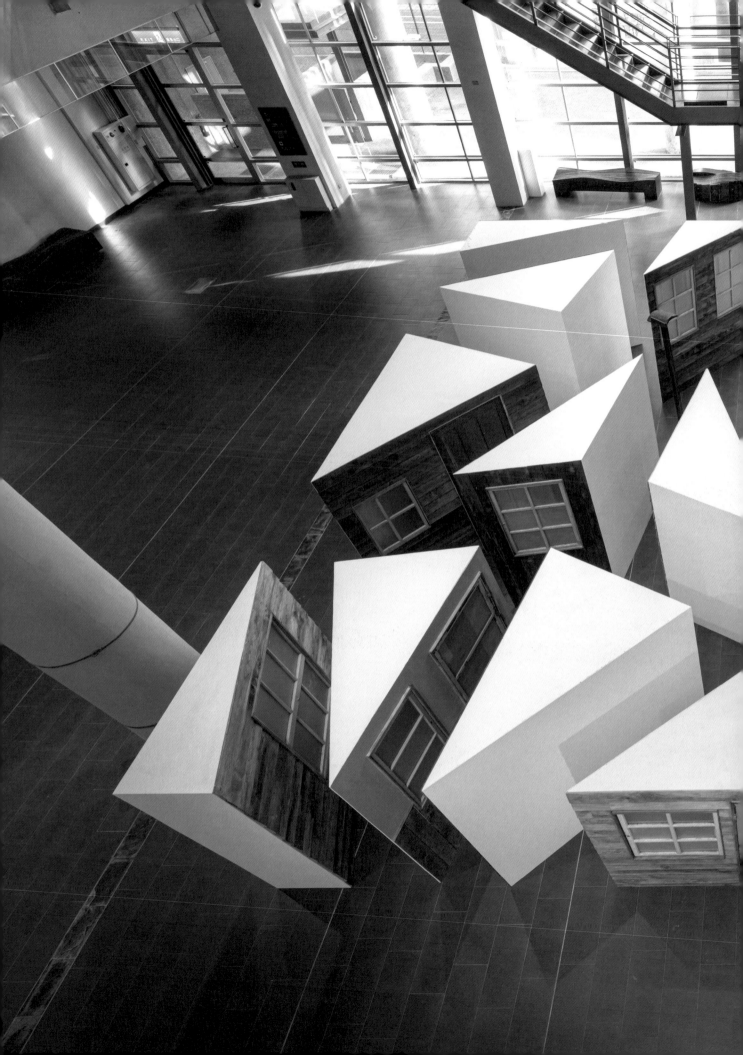

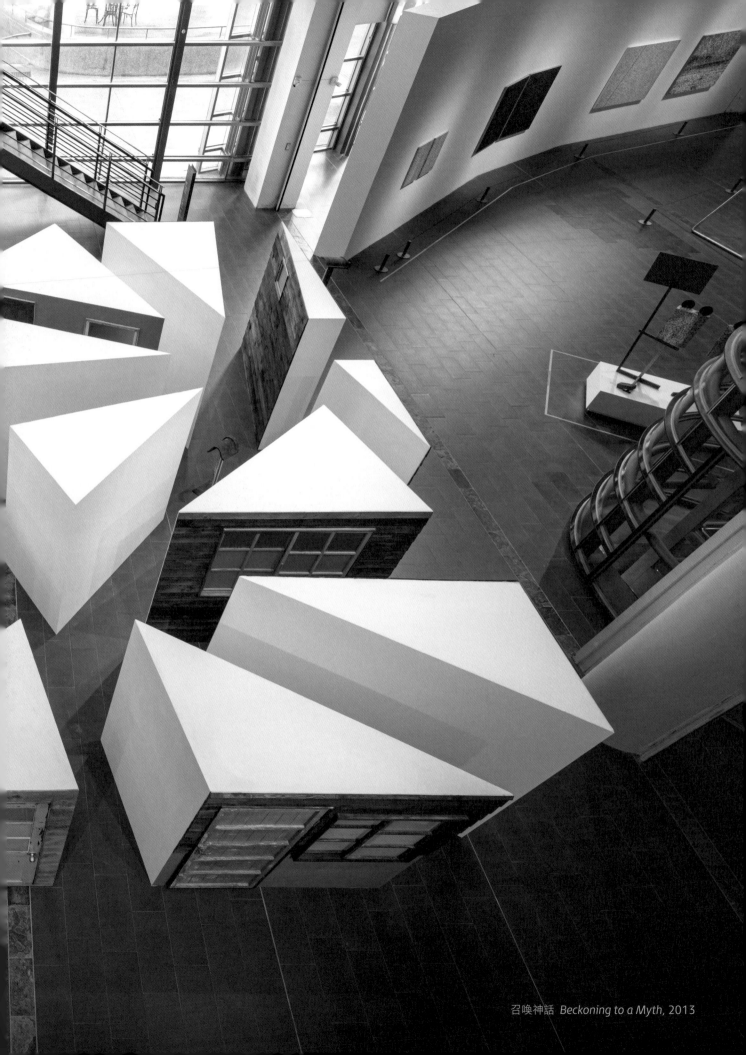

召喚神話 *Beckoning to a Myth*, 2013

四個方向 *Four Directions*, 2019

第一層秩序 *First Stage*, 2019

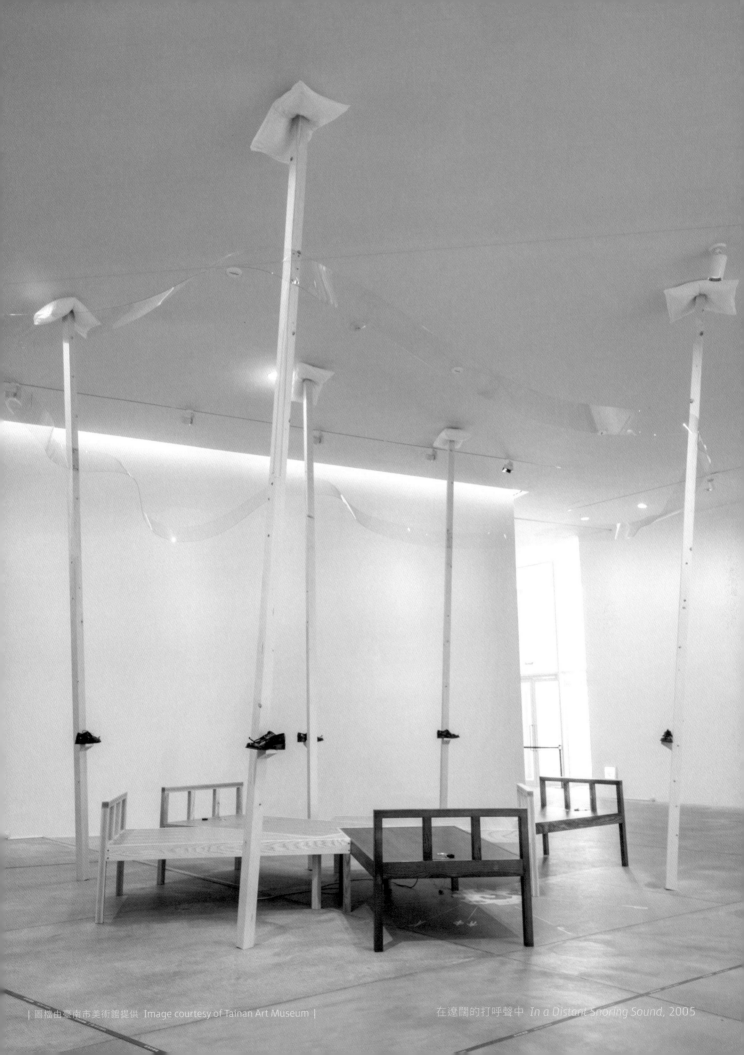

在遼闊的打呼聲中 *In a Distant Snoring Sound*, 2005

〈 在遼闊的打呼聲中 〉版畫系列 - 成長、發展、變化、繁殖、腐朽
In a Distant Snoring Sound - Growth, Development, Variation, Breeding, Decay. 2023

A/P　　　　　① 成長　　　　　　　　2023　渡辺

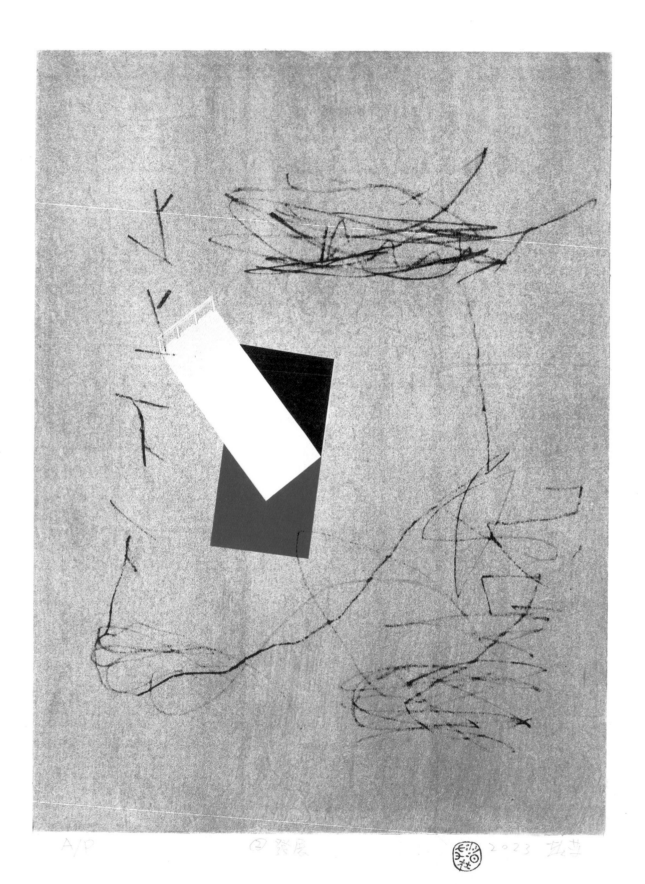

A/P ②發展 2023 哉也

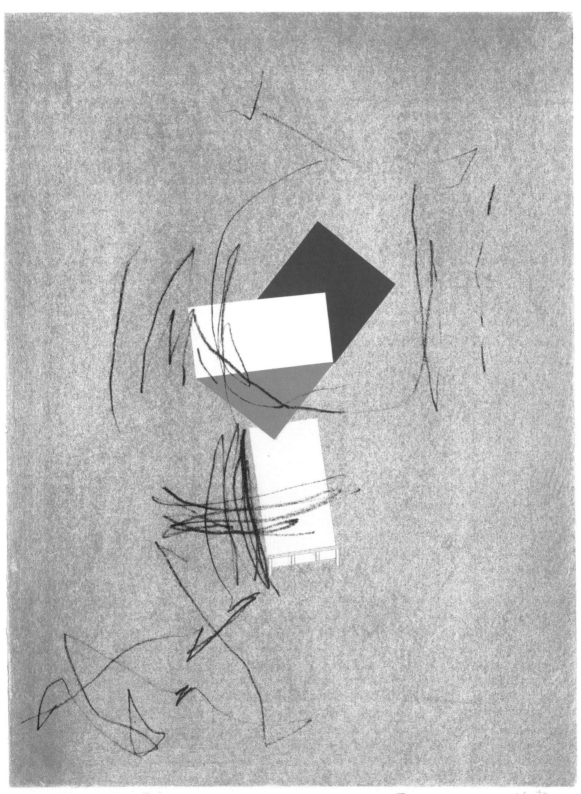

A/P　　　　③奎化　　　　　　　　　　　　2023.

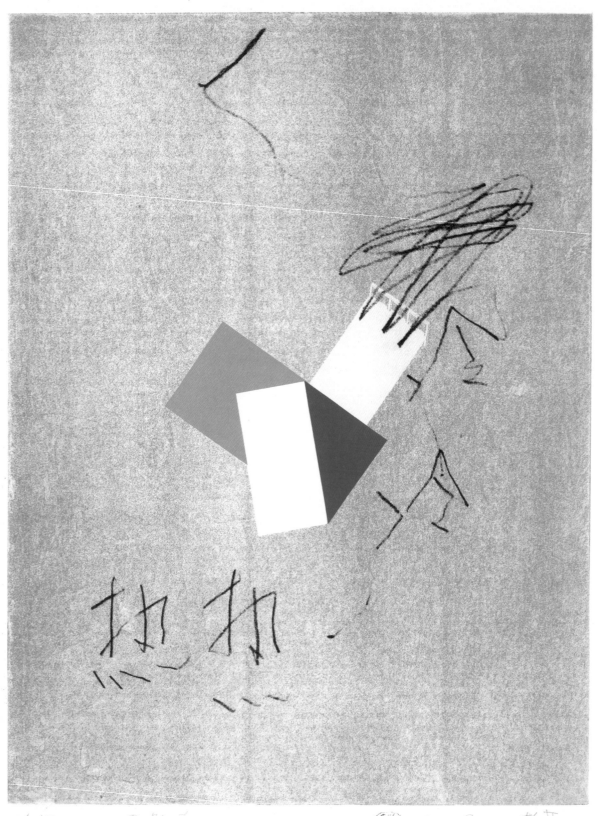

A/P ④黎明 2023 北平

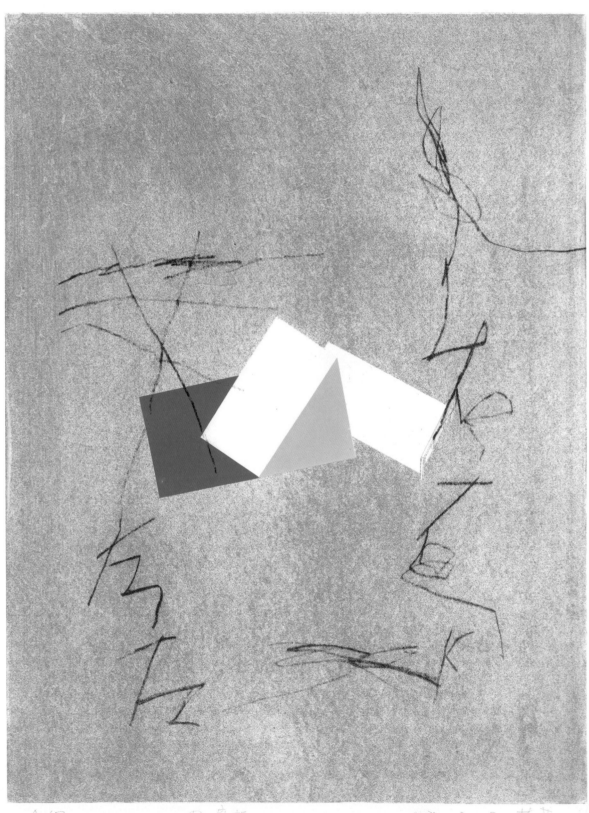

A/P 田 唐杉 2023 莊

自然的態度 *Composure,* 2016

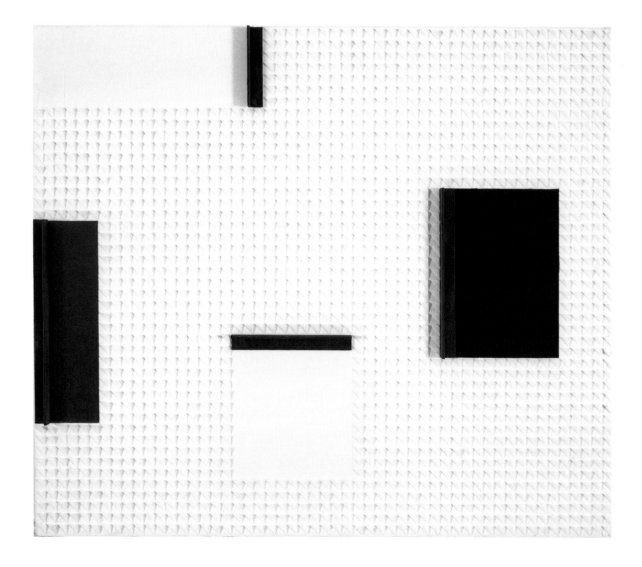

自我再製 *Autopoiesis,* 2019

地景化 *Landscape Formation*, 2016

告訴遠方的道路　*A Message to the Distant Road*, 2017

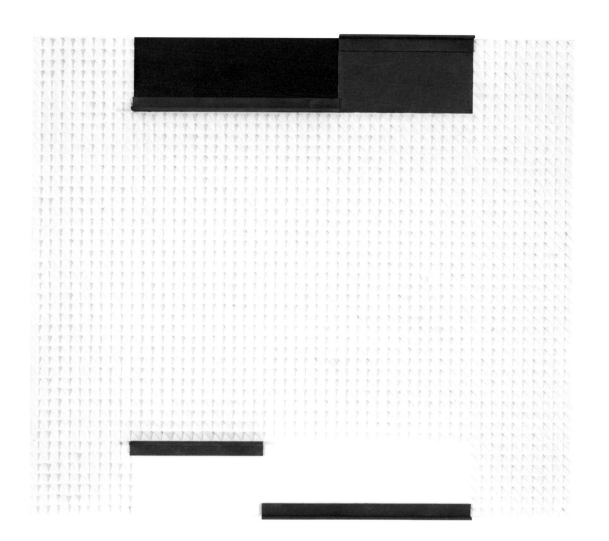

無有之地 *Nowhere,* 2019

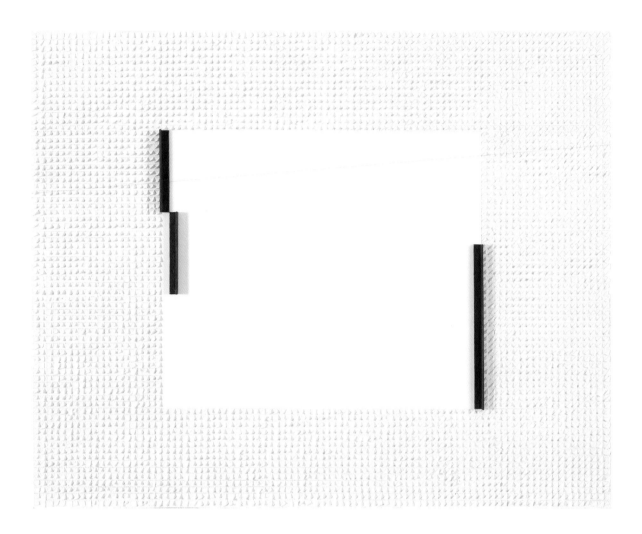

懸置 *Suspension*, 2016

眨眼 *Winks*, 2016

理極幽玄 *Occult,* 2019

綠遍山原白滿川 *Jade Mountains and Pearl River,* 2014

消散的近景 *Dissipation Close-up* , 1982

很多的目標和一個目標之二 *Many Goals and One -2*, 2023

跟曙光一同起身 *Rising with the Dawn,* 2023

草木山川風雨　*Greenery, Mountain, River, Wind, Rain*, 2023

幻滅之國 *Kingdom of Disillusion*, 1992

掛著 *Hanging,* 1989

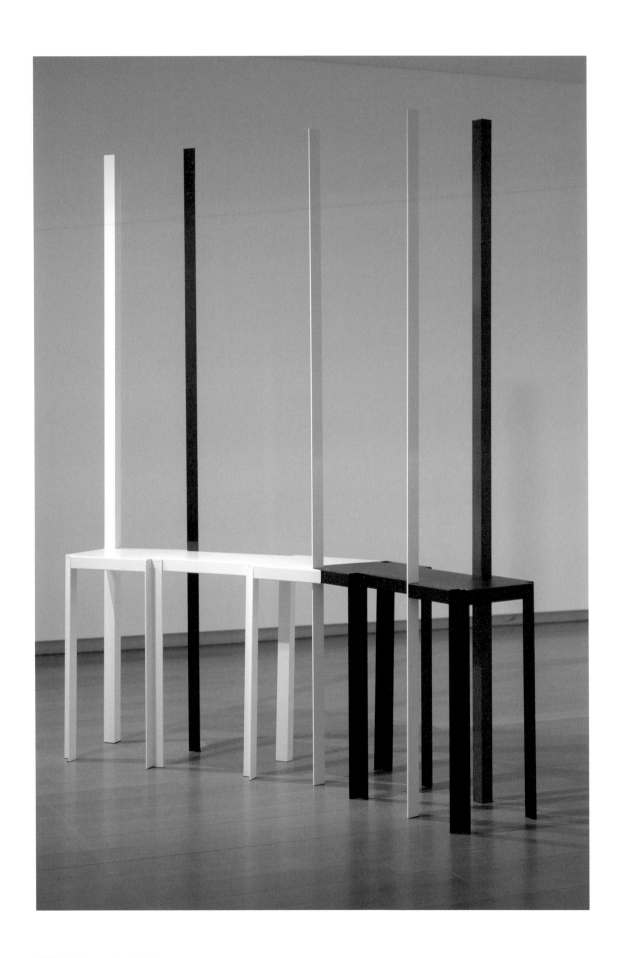

朗道 *Colonnade*, 2017

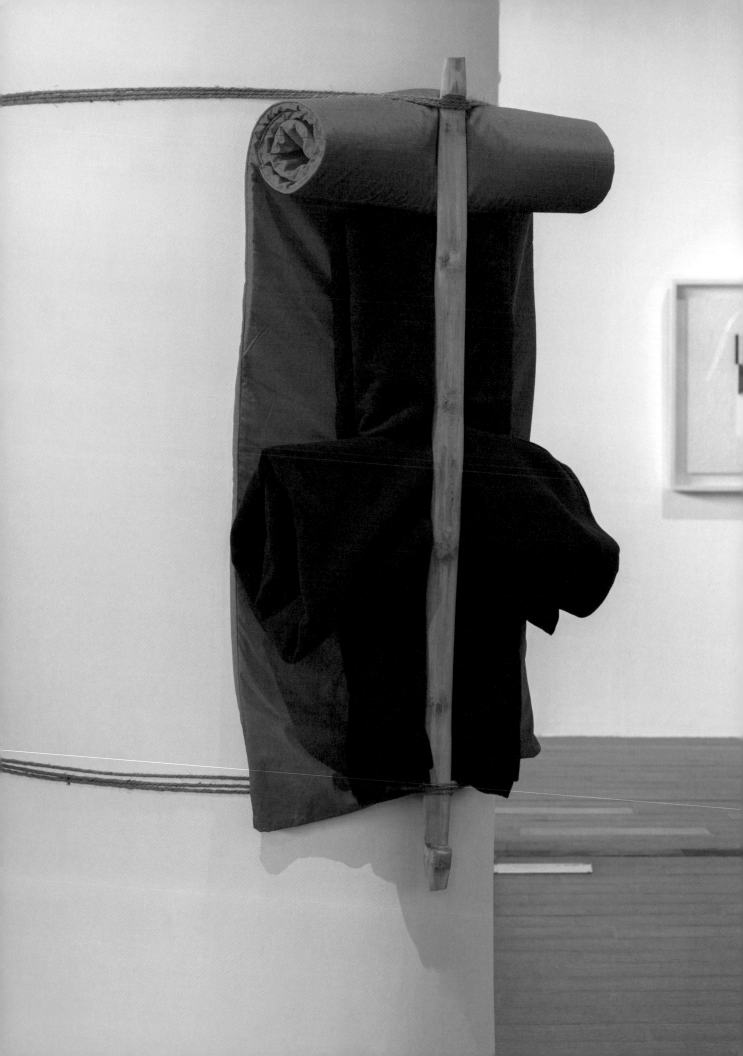

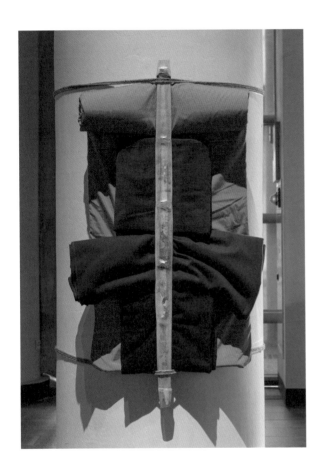 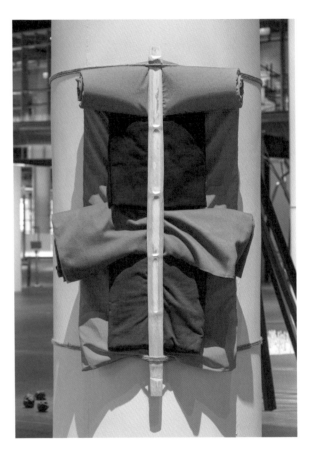

即刻峇里島 *Instant Bali,* 2023

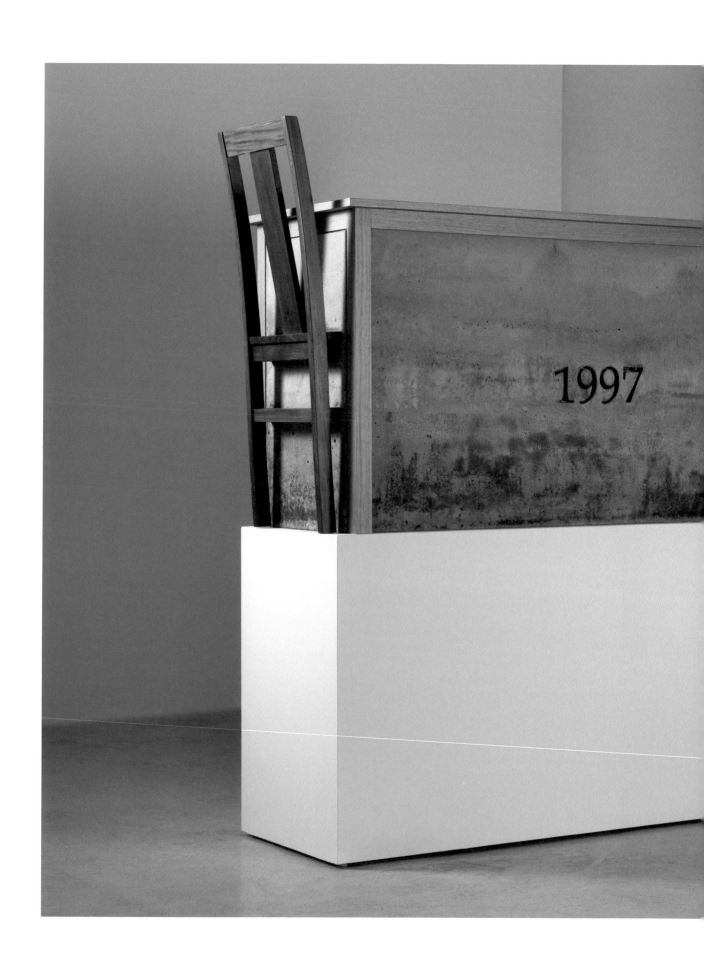

1997 紀念碑　1997 *Monument*, 1996

五月 *May,* 1990

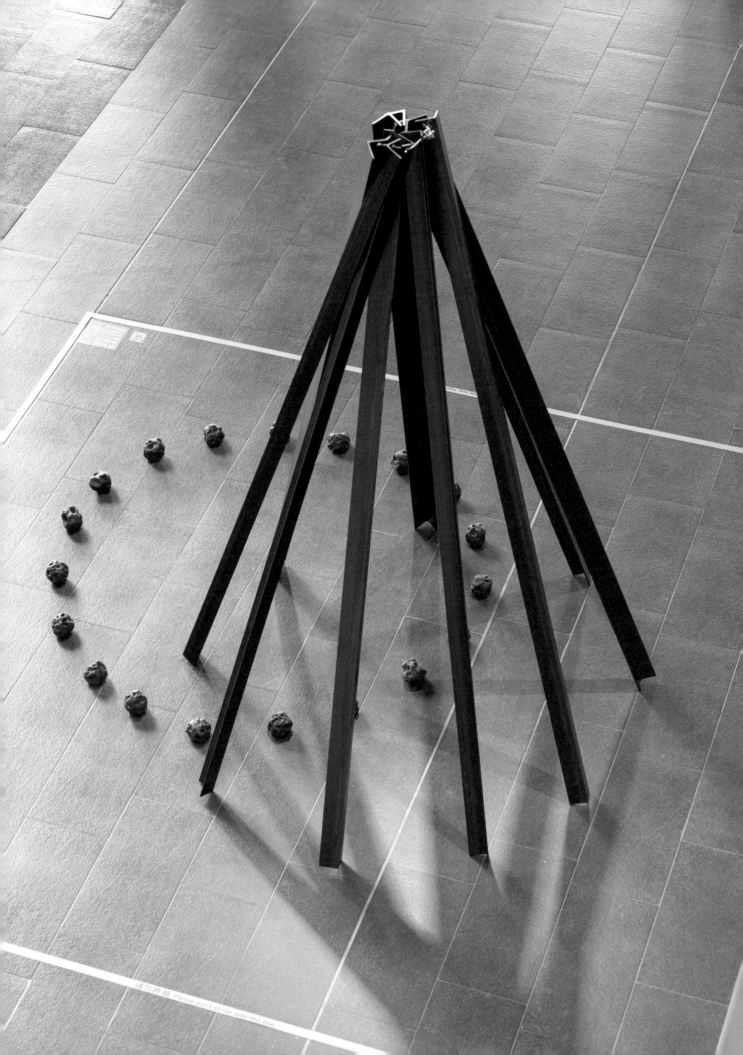

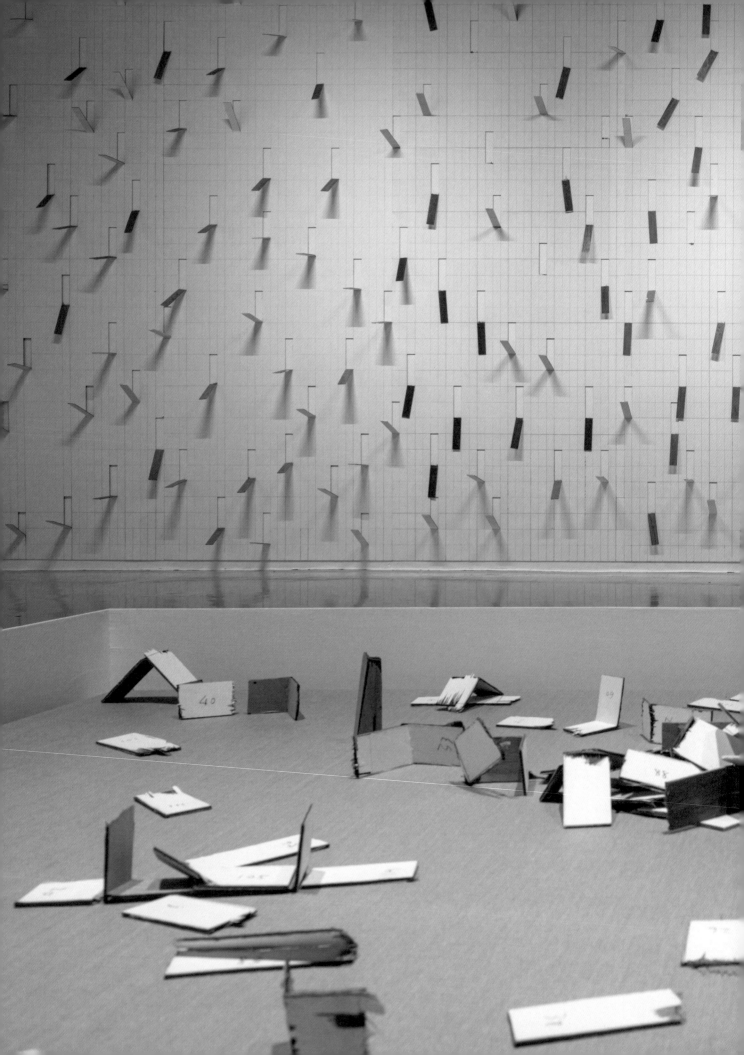

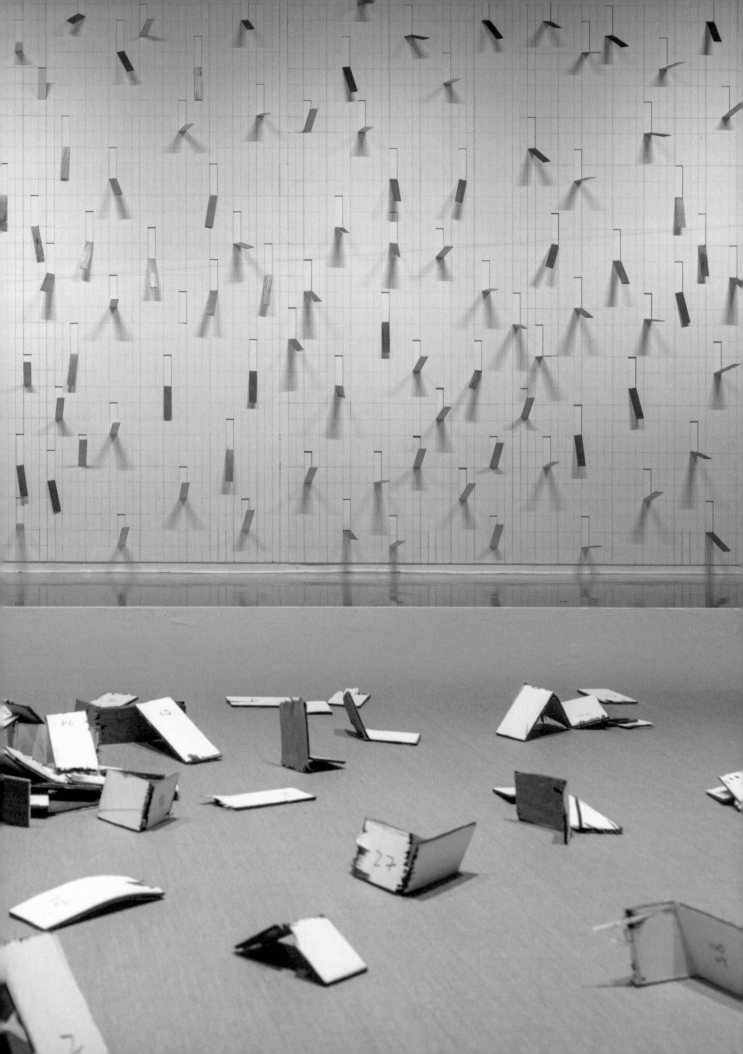

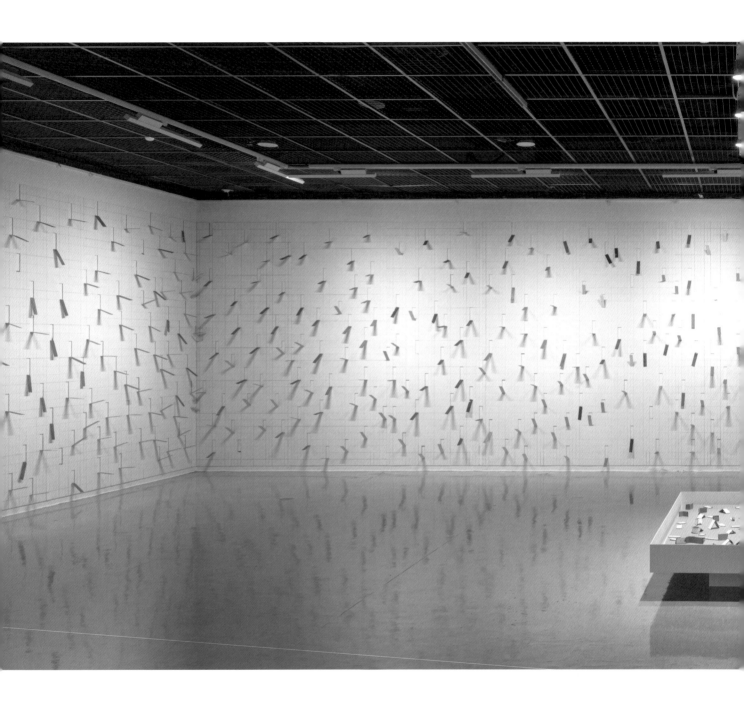

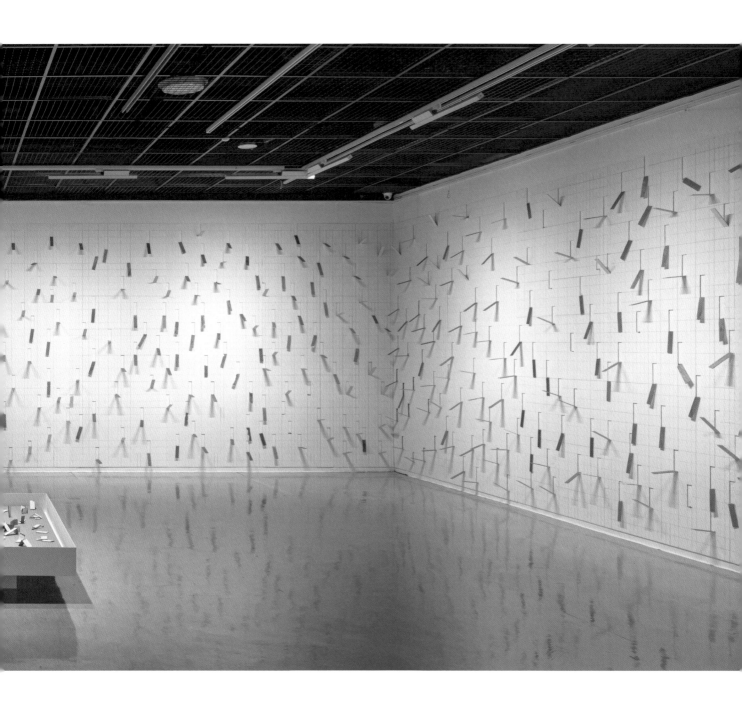

逃離現場 *Escape the Scene,* 1992　　189

轉風 *Veering Wind*, 1999

邂逅後的誘惑 II *Enticing Encounter II*, 1985 　　193

我討厭村上隆 我討厭奈良美智 *I Hate Takashi Murakami, I Hate Yoshitomo Nara,* 2008

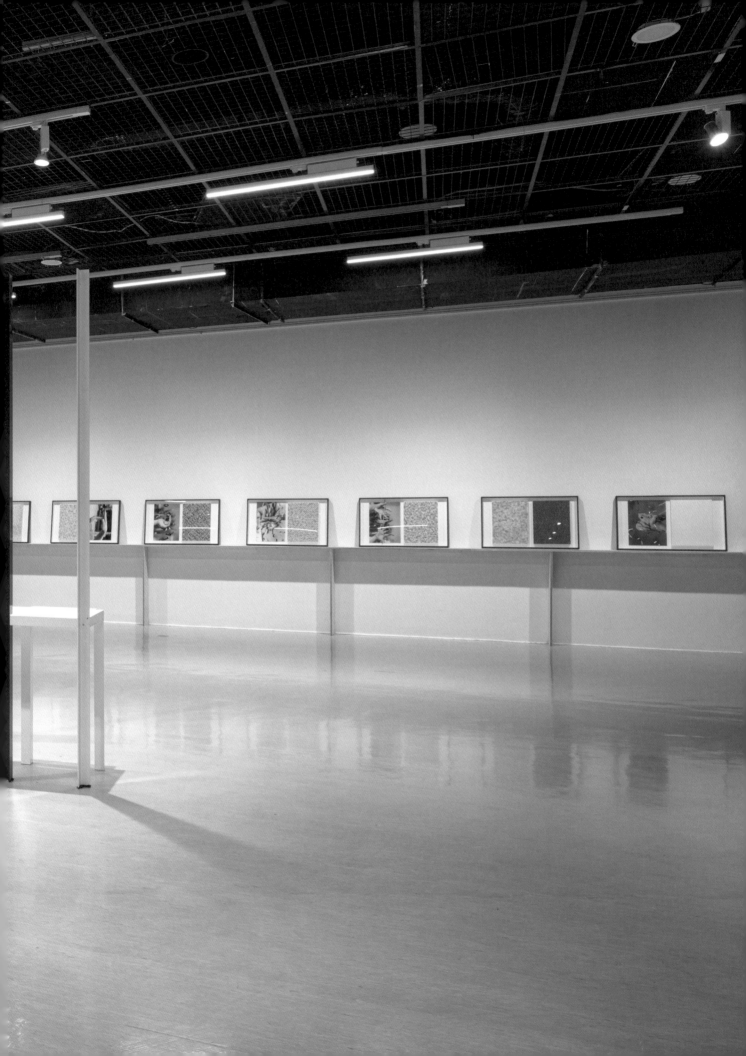

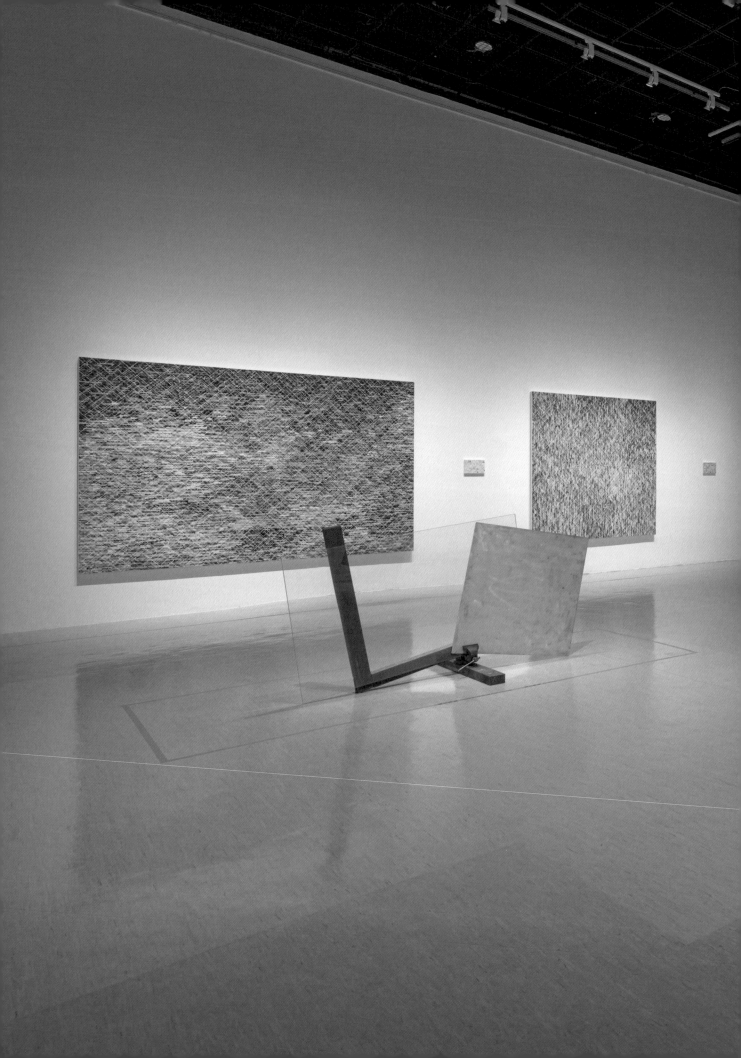

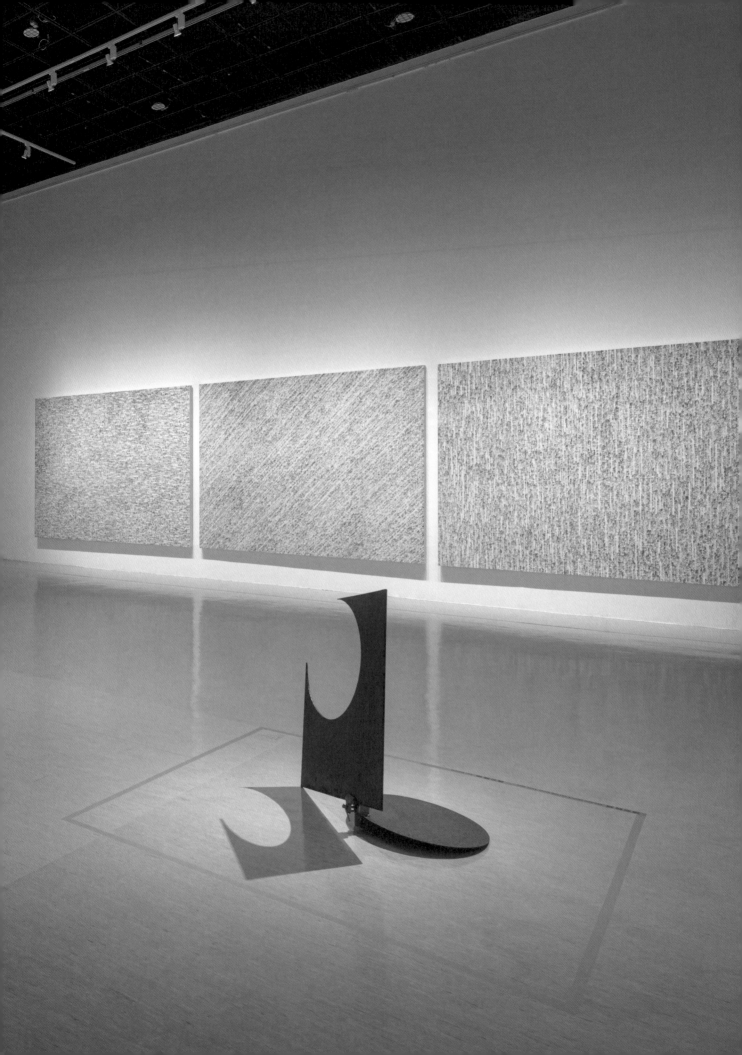

因觀 *Perceiving Cause*, 1999

霜彩 *The Color of Frost,* 1999

202 新店男孩（陳順築、莊普、吳東龍、蘇匯宇）Xindian Boys (Chen Shun-Chu, Tsong Pu, Wu Dong-Lung, Su Hui-Yu)

生活的決心 *The Determination of Life* , 2012

新店男孩（莊普、吳東龍、蘇匯宇）Xindian Boys (Tsong Pu, Wu Dong-Lung, Su Hui-Yu)

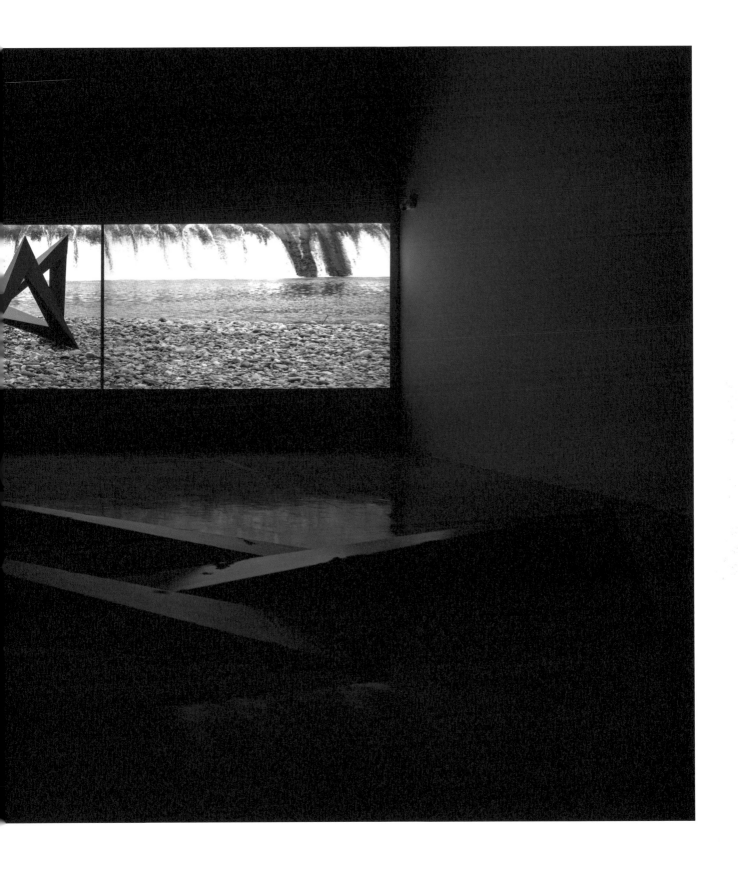

星際迷航 *Lost in Interstellar Space* , 2016

仗凝・時見 *Of an Imposing Manner, Seeing Frequently,* 1999

藝術家年表
Artist's Chronology

莊普

個人生平

1947 上海出生
1969 臺北私立復興美工畢業
1978 西班牙馬德里大學畢業
1981 回臺定居

得獎紀錄

2021 第十五屆文馨獎 銅獎，文化部，臺灣
2019 第二十一屆國家文藝獎 視覺藝術類，行政院財團法人國家文化藝術基金會，臺灣
　　　第十四屆文馨獎 銀獎，文化部，臺灣
2014 第四屆公共藝術獎 卓越獎，文化部，臺灣
2012 第三屆公共藝術獎，臺北市政府捷運工程局，臺灣
2009 伊通公園獲得第十三屆臺北文化獎，臺北市政府文化局，臺灣
2007 第一屆公共藝術獎 最佳創意表現獎，行政院文化建設委員會，臺灣
1992 臺北現代美術雙年展獎，臺北市立美術館，臺灣
1985 雄獅美術雙年展獎，臺北，臺灣
1984 中國現代繪畫新展望臺北市長獎，臺北市立美術館，臺灣

個展紀錄

2023 「越野的靈光：莊普個展」，國立臺灣美術館，臺中，臺灣
2022 「遠方的吸引」，誠品畫廊，臺北，臺灣
　　　「印記／迴盪／詩篇 —— 莊普個展」，創價美術館，臺北／彰化／臺南／桃園，臺灣
2021 「莊普新『境』展」，國立陽明交通大學 —— 藝文中心，新竹，臺灣
　　　「手的競技場」，國立中央大學 —— 藝文中心，桃園，臺灣
2019 「幻覺的宇宙」，誠品畫廊，臺北，臺灣
2017 「晴日換雨・緩慢焦點」，誠品畫廊，臺北，臺灣
2016 「莊普大型作品展 2008-2015」，大趨勢畫廊，臺北，臺灣
2015 「白・意識流」，月臨畫廊，臺中，臺灣
　　　「五彩竹 —— 莊普的拾貳獨白」，北京現在畫廊，北京，中國
2014 「光陰的聚落」，大趨勢畫廊，臺北，臺灣

「召喚神話」，大趨勢畫廊，臺北，臺灣

2013　「破碎的光・相互閱讀」，月臨畫廊，臺中，臺灣

「閃耀的星塔」，Apartment of Art，幕尼黑，德國

2012　「斜角上遇馬遠」，大趨勢畫廊，臺北，臺灣

「末日漂流」，關渡美術館，臺北，臺灣

「7,034,071,329 之 1」，加力畫廊，臺南，臺灣

2011　「粼粼 —— 莊普個展」，榮嘉文化藝術基金會，新竹，臺灣

2010　「莊普地下藝術展」，臺北市立美術館，臺北，臺灣

「疏遠的節奏」，大趨勢畫廊，臺北，臺灣

「遠方的座標」，國立中興大學藝文中心，臺中，臺灣

2008　「我討厭村上隆」，伊通公園，臺北，臺灣

「弱水三千・只取一瓢」，大趨勢畫廊，臺北，臺灣

2005　「在遼闊的打呼聲中」，伊通公園，臺北，臺灣

2004　「我看 —— 莊普個展」，二十號倉庫，臺中，臺灣

2001　「天旋地轉」，原型藝術，臺南，臺灣

「非常抱歉」，伊通公園，臺北，臺灣

1999　「在線上」，誠品畫廊，臺北，臺灣

1998　「莊普個展」，元智大學，桃園，臺灣

1997　「你就是那美麗的花朵」，伊通公園，臺北，臺灣

「莊普個展」，臻品藝術中心，臺中，臺灣

1995　「遊移美術館：名字與倉庫」，竹圍工作室，臺北，臺灣

1993　「真愛不滅」，伊通公園，臺北，臺灣

1991　「蠻荒原質」，阿普畫廊，高雄，臺灣

1990　「一棵樹・一塊岩石・一片雲」，串門藝術空間，高雄，臺灣

「軀體與靈魂之空間」，臺北市立美術館，臺北，臺灣

1989　「一棵樹・一塊岩石・一片雲」，高地畫廊，關卡，西班牙

1985　「邂逅後的誘惑」，春之藝廊，臺北，臺灣／名門畫廊，臺中，臺灣

1983　「心靈與材質的邂逅」，春之藝廊，臺北，臺灣／三采藝術中心，臺中，臺灣

聯展紀錄

2023　「第二屆馬祖國際藝術島 —— 生紅過夏」，連江，臺灣

2022　「家加 Homen」臻品 32 週年展，臻品藝術中心，臺中，臺灣

「非常態 —— 臺灣亞洲國際美展會員展」，大新美術館，臺南，臺灣

2021　「所在 —— 境與物的前衛藝術 1980-2021」，國立臺灣美術館，臺中，臺灣

「勒法利計畫」，空總臺灣當代文化實驗場，臺北，臺灣

「無名之年」，新店男孩，非常廟藝文空間，臺北，臺灣

2021　「永聲花 —— 無盡的聲音風景」，臺南市美術館，臺南，臺灣

　　　「藝／牆之佮」，白石畫廊，臺北，臺灣

2020　「彼方之境」，問空間，臺北，臺灣

　　　「像藝術家思考」，241藝術空間，新竹，臺灣

2019　「第27屆亞細亞現代雕塑家協會作品年展」，華山1914，臺北，臺灣

　　　「聚‧距 —— 當代藝術家創作展」，68當代藝術空間，宜蘭，臺灣

　　　「捉‧影 —— 2019國際當代Drawing展」，國父紀念館，臺北，臺灣

　　　「海峽兩岸抽象藝術交流展」，耘非凡美術館，臺南，臺灣

　　　「不可見的維度 莊普 × 徐婷」，Inart Space加力畫廊，臺南，臺灣

　　　「看見彩虹」，誠品畫廊，臺北，臺灣

2018　「自成徑 —— 臺灣境派藝術」，伊通公園，臺北，臺灣

　　　「無關像不像」，臺北市立美術館，臺北，臺灣

　　　「低限‧冷抽‧九人展」，耘非凡美術館，臺南，臺灣

2017　「星際迷航 RED —— 新店男孩」，雙方藝廊，臺北，臺灣

2016　「一座島嶼的可能性 —— 新店男孩」，國立臺灣美術館，臺中，臺灣

　　　「未來請柬」當代藝術展，人文遠雄博物館，臺北／汐止，臺灣

2015　「超驗與象徵」，尊彩藝術中心，臺北，臺灣

　　　「新店男孩」，雙方藝廊，臺北，臺灣

2014　「誠品畫廊25週年展」，誠品畫廊，臺北，臺灣

2013　「斜面連結 —— 典藏展實驗計畫」，臺北市立美術館，臺北，臺灣

　　　「亞洲巡弋 —— 物體事件」，關渡美術館，臺北，臺灣

　　　「山海線上 —— 五人聯展」，荷軒新藝空間，高雄，臺灣

　　　「在地與他方的力量 —— 臺灣當代藝術的感性與座標」，屏東美術館，屏東，臺灣

2012　「當空間成為事件 —— 臺灣，1980年代現代性部署」，高雄市立美術館，高雄，臺灣

　　　「非形之形→臺灣抽象藝術」，臺北市立美術館，臺北，臺灣

　　　「生活的決心 —— 新店男孩」，非常廟藝文空間，臺北，臺灣

　　　「集合物語 —— 藝術的日常遊戲」，二十號倉庫，臺中，臺灣

2011　「『返本歸真』臺灣當代抽象繪畫展 I」，赤粒藝術，臺北，臺灣

2010　「每一個花萼都是棲息之所 —— 第十三屆臺北文化獎『伊通公園』推廣活動」，

　　　　臺北市政府大樓中庭，臺北，臺灣

　　　「臺灣當代幾何抽象藝術的變奏」，誠品畫廊，臺北，臺灣

　　　「異象 —— 典藏抽象繪畫展」，國立臺灣美術館，臺中，臺灣

　　　「臺北現代畫展」，淡江大學文錙藝術中心展覽廳，臺北，臺灣

　　　「忠誠祝福 —— 臻品藝術中心二十週年策劃展」，臻品藝術中心，臺中，臺灣

2009　「觀點與『觀』點：2009亞洲藝術雙年展」，國立臺灣美術館，臺中，臺灣

2008　「小甜心 —— 伊通公園二十週年慶」，伊通公園，臺北，臺灣

　　　「家 —— 台灣美術雙年展」，國立臺灣美術館，臺中，臺灣

「抽象與材質的當代開拓」，印象畫廊當代館，臺北，臺灣

「不設防城市 ── 藝術中的建築展」，臺北市立美術館，臺北，臺灣

2007 「世代・對話」，印象畫廊當代館，臺北，臺灣

「形色版圖 ── 顛覆與重建」，大趨勢畫廊，臺北，臺灣

「散步 ── 莊普、賴純純、陳慧嶠 三人展」，伊通公園，臺北，臺灣

2006 「臺北二三：二三觀點」，臺北市立美術館，臺北，臺灣

2005 「二〇〇五關渡英雄誌 ── 臺灣現代美術大展」，關渡美術館，臺北，臺灣

「線性書寫」，臺北市立美術館，臺北，臺灣

2004 「幾何・抽象・詩情」，臺北市立美術館，臺北，臺灣

「藝術家博覽會」，華山藝文特區，臺北，臺灣

「立異 ── 90年代臺灣美術發展」，臺北市立美術館，臺北，臺灣

2003 「心靈重建三部曲 ── 歌頌生命百人聯展」，臺北市立美術館，臺北，臺灣

「64種愛的欲言 ── 在SARS漫延的年代」，伊通公園，臺北，臺灣

「我的名字 ── 裝置藝術展」，明新科技大學，新竹，臺灣

2002 「臺灣當代藝術」，鳳甲美術館，臺北，臺灣

「一場要命的幻象」，伊通公園，臺北，臺灣

「遠方的現實」，伊通公園，臺北，臺灣

2001 「輕且重的震撼 ── 臺北當代藝術館開幕展」，臺北當代藝術館，臺北，臺灣

「航向新世紀」，大趨勢畫廊，臺北，臺灣

2000 「千濤拍岸 ── 臺灣美術一百年」，關渡美術館，臺北，臺灣

1999 「磁性書寫 ── 念念之間紙上作品專題展」，伊通公園，臺北，臺灣

1998 「君自故鄉來」，竹圍工作室，臺北，臺灣

「臺北後花園裝置藝術展／休息一下 馬上就來！」，華山行館，臺北，臺灣

「臺灣省立美術館十週年慶／夜焱圖 ── 飛蛾撲火」臺灣省立美術館，臺中，臺灣

「臺南文藝季／照亮運河 ── 送給河流的一張床」，臺南，臺灣

1997 「伊通公園／臺北市立美術館聯展」，臺北市立美術館，臺北，臺灣

「混亂時代中的重結構 高雄鹽埕畫廊開幕聯展」，鹽埕畫廊，高雄，臺灣

1996 「黑色繪」，帝門藝術中心，臺北，臺灣

「臺北市立美術館雙年展 ── 六月裡的後花園」，臺北市立美術館，臺北，臺灣

「五月畫展／獨立宣言」，大未來畫廊，臺北，臺灣

「陶藝聯展 ── 不適於合唱的空間」，臺北縣立文化中心，臺北，臺灣

1995 「南方性格」，悠閒藝術中心，臺北，臺灣

「位置 飛機場」，伊通公園，臺北，臺灣

1994 「材質與心靈的對話」，家畫廊，臺北，臺灣

「漫無目的」，伊通公園，臺北，臺灣

「都會中的自然」，帝門藝術中心，臺北，臺灣

「纖維」，二號公寓，臺北，臺灣

1994	「單色繪畫」，愛力根畫廊，臺北，臺灣
	「無可描述的未知」，伊通公園，臺北，臺灣
1993	「停頓世界 —— 影像專題展」，伊通公園，臺北，臺灣
	「花姿招展／想花心比看花深」，伊通公園，臺北，臺灣
	「傳統與創新 —— 中華花藝國際花卉展」，臺北世貿中心，臺北，臺灣
	「亞熱帶植物」，誠品藝文空間，臺北，臺灣／臻品藝術中心，臺中，臺灣
	「莊普、胡坤榮、賴純純 三人展」，伊通公園，臺北，臺灣
	「送禮文化」，新生態藝術環境，臺南，臺灣
	「IT KITSCH 愛的禮物」，伊通公園，臺北，臺灣
1992	「藝術博覽會」，松山外貿協會，臺北，臺灣
	「把觀念穿在身上」，伊通公園，臺北，臺灣
	「16種處理垃圾的想法／環境與藝術」，臺北縣立文化中心，臺北，臺灣
	「臺北現代美術雙年展」，臺北市立美術館，臺北，臺灣
	「從物體開始」，伊通公園，臺北，臺灣
	「臺灣泥雅畫廊開幕聯展」，泥雅畫廊，臺北，臺灣
1991	「巫展」，伊通公園，臺北，臺灣
	「國際郵遞藝術交流展」，伊通公園，臺北，臺灣
	「書店裡的裝置」，誠品書店，臺北，臺灣
	「91臺灣當代繪畫趨向」，悠閒藝術中心，臺北，臺灣
	「行上與物性之間 —— 莊普、葉竹盛、黎志文 三人展」，阿普畫廊，高雄，臺灣
	「現代繪畫12人展」，帝門藝術中心，臺北，臺灣
1990	「詩與新環境」，誠品畫廊，臺北，臺灣
	「阿普畫廊開幕聯展」，阿普畫廊，高雄，臺灣
	「臺灣美術300年作品」，臺灣省立美術館，臺中，臺灣
	「永漢畫廊開幕聯展」，永漢畫廊，臺北，臺灣
	「伊通公園開幕聯展」，伊通公園，臺北，臺灣
	「當代畫家素描聯展」，誠品畫廊，臺北，臺灣
1988	「媒體・環境・裝置」，臺灣省立美術館，臺中，臺灣
	「莊普、曲德義 雙人展」，誠品畫廊，臺北，臺灣
	「時代與創新」，臺北市立美術館，臺北，臺灣
1987	「中華民國當代繪畫聯展」，臺北國立歷史博物館，臺北，臺灣
	「行為與空間」，臺北市立美術館，臺北，臺灣
1986	「中國現代繪畫新展望」，臺北市立美術館，臺北，臺灣
	「SOCA 現代藝術工作室開幕聯展」，SOCA 現代藝術工作室，臺北，臺灣
1985	「前衛・裝置・空間特展」，臺北市立美術館，臺北，臺灣
	「超度空間 —— 色彩・結構・空間」，春之藝廊，臺北，臺灣
	「雄獅美術雙年展」，雄獅畫廊，臺北，臺灣

1984　「異度空間 —— 空間的主題‧色彩的變奏展」，春之藝廊，臺北，臺灣

1983　「新象藝術中心開幕聯展」，新象藝術中心，臺北，臺灣

　　　「臺北市立美術館開幕聯展」，臺北市立美術館，臺北，臺灣

1982　「陳世明、程延平、莊普 三人展」，春之藝廊，臺北，臺灣

1979　「當代海外藝術家聯展」，國立歷史博物館，臺北，臺灣

國外參展

2023　「塵世‧境 —— 臺灣80年代藝術家聯展」，婆仔屋文創空間，澳門，中國

2021　「第29屆亞洲國際美術展覽會」，九州藝文館，福岡，日本

2014　「我們從未參與 —— 第八屆深圳雕塑雙年展」，OCT當代藝術中心，深圳，中國

2012　「第27屆亞洲國際美術展覽會」，拉加達曼仁當代藝術中心，曼谷，泰國

2011　「第26屆亞洲國際美術展覽會」，首爾藝術中心漢嘉阮美術館，首爾，韓國

　　　「複感‧動觀 —— 2011海峽兩岸當代藝術展」，中國美術館，北京，中國

2009　「普‧天‧同‧慶 —— 莊普、吳天章雙個展」，藝術北京當代藝術博覽會，北京，中國

　　　「第一接觸 —— 臺北‧昆明‧香港當代藝術聯展」，99藝術空間，昆明，中國

2008　「Art is Alive —— 釜山雙年展2008」，釜山當代藝術館，釜山，韓國

2006　「巴黎首都藝術 —— 聯合沙龍大展」，大皇宮，巴黎，法國

　　　「PASS —— 經過」，名古屋藝術大學藝術與設計中心，名古屋，日本

　　　「臺灣美術發展1950～2000」，中國美術館，北京，中國

2005　「臺灣現代藝術展」，昆明市博物館，昆明，中國

2004　「福爾摩沙臺灣當代藝術展」，帝歐席薩主教博物館，巴塞隆那，西班牙

2002　「Chinese Ink Tree / 無限的改變 III」，維魯艾拉修道院，薩拉戈薩，西班牙

　　　「海洋錯合 —— 歷史的物殖」，婆仔屋藝術空間，澳門，中國

　　　「止 —— 韓國光州雙年展」，光州廣域市立美術館，光州，韓國

2001　「臺北當代藝術展」，上海現代美術館，上海，中國

2000　「文字的遊戲」，水牛城大學藝術中心，紐約，美國

1999　「複數元的視野／臺灣當代美術1988～1999」，中國美術館，北京，中國

1998　「巴黎今日大師與新秀大展 —— 40週年特展」，巴黎，法國

　　　「國際雕塑創作營 —— 你是盡頭 我是石頭 他是骨頭」，桂林愚自樂園，中國

　　　「內外翻轉／中國新藝術」，PS1美術館，紐約／舊金山現代美術館，美國

1997　「裂合與聚生：三位臺灣藝術家」，第47屆威尼斯雙年展，威尼斯，義大利

1996　「中國旅程97 —— 兩岸三地的裝置藝術展」，香港科技大樓，香港

　　　「臺北當代藝術展」，上海市立美術館，中國

1995　「臺灣當代藝術展」，澳洲巡迴展，澳洲

1994　「臺北現代畫展」，國家畫廊，曼谷，泰國

　　　「臺灣當代藝術展」，港邊畫廊，橫濱，日本

1989　「臺北訊息展」，原美術館，東京，日本

1987　「中國當代繪畫展」，漢城現代美術館，首爾，南韓

1986　「國際現代藝術邀請展」，橫濱，日本

1980　「中日雙人展」，桑坦德市旅遊文化局展覽廳，桑坦德市，西班牙

　　　「雙人展」，布伊沙梭畫廊，札拉哥沙，西班牙

1979　「全歐中國畫家藝術聯盟展」，金龍畫廊，布魯塞爾，比利時

　　　「三人展」，布斯根畫廊，西班牙

　　　「三人展」，藝術角畫廊，馬德里，西班牙

典藏紀錄

2021　〈吸吮迴路〉、〈晴日換雨〉、〈七日之修〉、〈勞動紀念碑〉、〈精神之塔〉，新北市美術館，
　　　新北，臺灣

　　　〈1997紀念碑〉、《手的競技場》，國立臺灣美術館，臺中，臺灣

　　　〈心靈與材質的邂逅 II〉、〈掛著〉、〈幻滅之國〉、〈你就是那美麗的花朵〉、〈尺度外〉、
　　　〈一片雲 一塊石 一棵樹〉、〈水泥中的花朵〉，臺北市立美術館，臺北，臺灣

2020　〈幻覺的宇宙〉、〈曜〉、〈咫尺天涯〉，臺北市立美術館，臺北，臺灣

2019　〈港都太陽〉，高雄市立美術館，高雄，臺灣

2018　〈祖靈的眼睛〉、〈間隔一道〉，國立臺灣美術館，臺中，臺灣

2010　〈六月裡的後花園〉、〈在遼闊的打呼聲中〉、〈表現之光〉，臺北市立美術館，臺北，臺灣

2009　〈閃耀的交會〉，國立臺灣美術館，臺中，臺灣

2000　〈轉風〉，高雄市立美術館，高雄，臺灣

1998　〈遨遊四方〉，國立臺灣美術館，臺中，臺灣

1995　〈秘密的裝潢－鋯〉、〈自畫像〉，臺北市立美術館，臺北，臺灣

1994　〈位移〉、〈饒舌工廠〉，港邊畫廊，橫濱，日本

1992　〈光與水的移位〉，臺北市立美術館，臺中，臺灣

1989　〈未知〉，原美術館，東京，日本

　　　〈黑與白〉，臺北市立美術館，臺北，臺灣

1984　〈顫動的線〉，臺北市立美術館，臺北，臺灣

公共藝術陳設紀錄

2010　〈新浪潮〉，海岸巡防總局南部地區巡防局 興達港海巡基地，高雄，臺灣

2008　〈光隙〉，臺北捷運南港展覽館站，臺北，臺灣

2006　〈科學家說：…〉，國家奈米元件實驗室，新竹，臺灣

2005　〈五張河床〉，臺北市政府環境保護局修車廠暨資源回收隊，臺北，臺灣

　　　〈歷史之梯〉，國道3號清水服務區，臺中，臺灣

2004 〈 速度的藝術 〉，臺灣大學體育館室內組，臺北，臺灣

〈 有逗點、句點的風景 〉，南港軟體園區，臺北，臺灣

〈 藝術家說 〉，臺北藝術大學關渡美術館，臺北，臺灣

2003 〈 世界之環 〉，臺北 101 國際金融中心，臺北，臺灣

〈 飲水思源 〉，內湖汙水處理廠，臺北，臺灣

1998 〈 輕鬆的雲、走路的樂 〉，臺北捷運中正紀念堂站，臺北，臺灣

Tsong Pu

Biography

1947 Born in Shanghai, China

1969 Graduated from Fu-Hsin Trade and Arts School

1978 Graduated from La Escuela Superior de Bellas Artes de San Fernando de Madrid, Spain

1981 Returned to Taiwan, lives and works in Taipei

Prizes and Awards

2021 "The 15th Arts & Business Awards", Excellence Award, Ministry of Culture, Taiwan

2019 "National Award for Arts", National Culture and Arts Foundation, Taiwan

 "The 14th Arts & Business Awards", Excellence Award, Ministry of Culture, Taiwan

2014 "The 4th Public Art Awards", Excellence Award, Ministry of Culture, Taiwan

2012 "The 3rd Public Art Awards", Department of Rapid Transit Systems, Taipei City Government, Taiwan

2009 "The 13th Taipei Culture Award" for IT Park Gallery, Taipei City Government
 Department of Cultural Affairs, Taiwan

2007 "The Best of Creativity", The 1st Public Art Awards, Council for Cultural Affairs (CCA), Taiwan

1992 "Taipei Biennial of Contemporary Art Award", Taipei Fine Arts Museum, Taipei, Taiwan

1985 "Taipei Hsiung Shih Biennial Exhibition", Taipei, Taiwan

1984 "Taipei City Mayor Award for A New Vision of Contemporary Chinese Painting", Taipei Fine
 Arts Museum, Taipei, Taiwan

Solo Exhibitions

2023 "Tsong Pu: Off-Road Aura", National Taiwan Museum of Fine Arts, Taichung, Taiwan

2022 "Imprints / Echoes / Poems:Tsong Pu Solo Exhibition", Soka Art Museum,Taipei/ Changhua /
 Tainan/ Taoyuan, Taiwan

 "Distant Proximity", Tsong Pu Solo Exhibition, Eslite Gallery, Taipei, Taiwan

2021 "New "Jing" – Tsong Pu Solo Exhibition", NYCU Arts Center, Hsinchu, Taiwan

 "Amphitheater of Hands: A Solo Exhibition of Tsong Pu", National Central University Art Center,
 Taoyuan, Taiwan

2019 "Illusions of the Universe, Tsong Pu Solo Exhibition", Eslite Gallery, Taipei, Taiwan

2017 "Against the Quotidian Tug", Tsong Pu Solo Exhibition, Eslite Gallery, Taipei, Taiwan

2016	"Tsong Pu Large-Scale Paintings 2008-2015", Main Trend Gallery, Taipei, Taiwan
2015	"A White Stream of Consciousness", Moon Gallery, Taichung, Taiwan
	"Tsong Pu's Twelve Monologues – Multicolored Bamboo", Beijing Art Now Gallery, Beijing
2014	"Settlement of time", Main Trend Gallery, Taipei, Taiwan
	"Beckoning to a Myth", Main Trend Gallery, Taipei, Taiwan
2013	"The Broken Light – Reading Each Other", Moon Gallery, Taichung, Taiwan
	"Der Turm der Leuchtenden Sterne", Apartment of Art, Munich, Germany
2012	"Ma Yuan at A Corner: 2012 Tsong Pu Solo Exhibition", Main Trend Gallery, Taipei, Taiwan
	"Drifting Towards An End", Kuandu Museum of Fine Arts, Taipei, Taiwan
	"One of 7,034,071,329", Inart Space, Tainan, Taiwan
2011	"Gleamingly Gleaming – Tsong Pu Solo Exhibition", Art Museum at The Art Park, Hsinchu, Taiwan
2010	"Art from the Underground: Tsong Pu Solo Exhibition", Taipei Fine Arts Museum, Taipei, Taiwan
	"Estranged Rhythm", Main trend Gallery, Taipei, Taiwan
	"Coordinates of The Distance: Tsong Pu Solo Exhibition", National Chung Hsing University Art Center, Taichung, Taiwan
2008	"I Hate Takashi Murakami", IT Park, Taipei, Taiwan
	"A Flood of Tender Water, I Take One Scoop Only", Main Trend Gallery, Taipei, Taiwan
2005	"Tsong Pu: The Spectacular Snore", IT Park, Taipei, Taiwan
2004	"I See I Seek", Warehouse 20, Taichung, Taiwan
2001	"Spinning Round and Round", None Theme Park, Tainan, Taiwan
	"I am Sorry", IT Park, Taipei, Taiwan
1999	"On Line", Eslite Gallery, Taipei, Taiwan
1998	"Tsong Pu 1998", Yuan Ze University Arts Center, Taoyuan, Taiwan
1997	"You Are the Beautiful Flower", IT Park, Taipei, Taiwan
	"Tsong Pu 1997", Galerie Pierre, Taipei, Taiwan
1995	"Name and Warehouse", Bamboo Curtain Studio, Taipei, Taiwan
1993	"Love Never Dies", IT Park, Taipei, Taiwan
1991	"The Frontier", UP Art Gallery, Kaohsiung, Taiwan
1990	"A tree, A Stone and A Piece of Cloud", Doors Art Space, Kaohsiung, Taiwan
	"The Space between Body and Soul", Taipei Fine Arts Museum, Taipei, Taiwan
1989	"A tree, A Stone and A Piece of Cloud", Sala Alta Gallery, Cuenca, Spain
1985	"Temptation after Meeting by Chance", Spring Gallery, Taipei, Taiwan/ Ming-Men Gallery, Taichung, Taiwan
1983	"A Meeting of Mind and Material", Spring Gallery, Taipei, Taiwan / San-Chai Gallery, Taichung, Taiwan

Group Exhibitions

2023 "Ruby Red after – 2nd Summer Matsu Biennial", Lienchiang, Taiwan

2022 "Home and Home" 20th Anniversary Exhibition", Galerie Pierre, Taichung, Taiwan

"Abnormal: Asian International Art Exhibition by Taiwan Committee Members", Da Xin Art Museum, Tainan, Taiwan

2021 "Places of Being – Space and Materiality in Taiwan's Avant-Garde Art, 1980-2021", National Taiwan Museum of Fine Arts, Taichung, Taiwan

"Project: The Folly", Taiwan Contemporary Culture Lab, Taipei, Taiwan

"The Untitled Year", The Xindian Boys, VT Artsalon, Taipei, Taiwan

"The Eternal Soundscape – A Myriad of Everlasting Memories", Tainan Art Museum, Tainan, Taiwan

"Matching of Arts and Walls", Whitestone Gallery, Taipei, Taiwan

2020 "The Other Realm", Wen Studio, Taipei, Taiwan

"Think Like An Artist", 241 Art Gallery, Hsinchu, Taiwan

2019 "27th The Exhibition of Art Works by The Associaition of Assian Contemporary Sculptors", Huashan 1914 Creative Park, Taipei, Taiwan

"Converge Distance", 68 Contemporary Art Space, Yilan, Taiwan

"Catch the Shadow – International Contemporary Drawing", The National Sun Yat-sen Memorial Hall, Taipei, Taiwan

"The Cross – Strait Abstract Painting Art Exchange Exhibition", Yun Fei Fan Museum, Tainan, Taiwan

"Invisible Dimension – TSONG Pu & Ting Hsu", In Art Space, Tainan, Taiwan

"OVER THE RAINBOW", Eslite Gallery, Taipei, Taiwan

2018 "Sui Generis: Jing-Pai of Taiwan", IT Park, Taipei, Taiwan

"Not About Resemblance", Taipei Fine Arts Museum, Taipei, Taiwan

"Minimalism Cold Abstraction – Contemporary Abstract Art in Taiwan", Yun Fei Fan Museum, Tainan, Taiwan

2017 "Interstellar-RED Xindan Boys", Xindian Boys, Double Square Gallery, Taipei, Taiwan

2016 "Taiwan Biennial the Possibility of an Island", National Taiwan Museum of Fine Arts, Taichung, Taiwan

"The Future Invitation", Farglory Museums, Taipei, Taiwan

2015 "Transcendence and Symbol", Liang Gallery, Taipei, Taiwan

"Xindian Boys", Double Square Gallery, Taipei, Taiwan

2014 "Eslite Gallery's 25th Anniversary Exhibition", Eslite Gallery, Taipei, Taiwan

2013 "Intersecting Vectors – Experimental Projects from the TFAM Collection", Taipei Fine Arts Museum, Taipei, Taiwan

"A Joint Exhibition by Five Artistson the Mountain – Coastal Lines", Lotus Art Gallery, Kaohsiung, Taiwan

"Asia Cruise", Kuandu Museum of Fine Arts, Taipei, Taiwan

"The Power(s) of Local and Elsewhere", Pingtung Art Museum, Pingtung, Taiwan

2012 "When Spaces Became Events... Dispositive of Modernity in the 1980s, Taiwan", Kaohsiung
 Museum of Fine Arts, Kaohsiung, Taiwan

"Xindian Boys – The determination of Life", VT Artsalon, Taipei, Taiwan

"Formless Form – Taiwanese Abstract Art", Taipei Fire Arts Museum, Taipei, Taiwan

"Daily Collection of Abstract Play", Warehouse 20, Taichung, Taiwan

2011 "Return to the Essence – Survey of Contemporary Abstract Painting in Taiwan I", Red Gold Fine Art,
 Taipei, Taiwan

2010 "Every Chalice is a Dwelling Place – Thirteenth Taipei Culture Award 'IT Park' Promotional Event",
 Taipei City Hall, Taipei, Taiwan

"Variations of Geometric Abstraction in Taiwan's Contemporary Art", Eslite Gallery, Taipei, Taiwan

"Beyond Vision: Highlights of Abstract Paintings from the National Taiwan Museum of Fine Arts
 Collection", National Taiwan Museum of Fine Arts, Taichung, Taiwan

"Taipei Modern Art Exhibition", Carrie Chang Fine Arts Center of Tamkang University, Taipei, Taiwan

"Loyalty Blessing", 20th Anniversary Exhibition, Galerie Pierre, Taichung, Taiwan

2009 "Viewpoints & Viewing Points – 2009 Asian Art Biennial", National Taiwan Museum of Fine Arts,
 Taichung, Taiwan

2008 "SWEETIES: Celebrating 20 Years of IT Park", IT Park, Taipei, Taiwan

"HOME – Taiwan Biennial 2008", National Taiwan Museum of Fine Arts, Taichung, Taiwan

"Contemporary Explorations in Abstraction and Materials", Impressions Art Gallery, Taipei, Taiwan

"Architecture in Art – OPEN CITY", Taipei Fine Arts Museum, Taipei, Taiwan

2007 "Generation Dialog", Impressions Art Gallery, Taipei, Taiwan

"STROLL: Tsong pu, Jun T. Lai, Chen Hui-Chiao", IT Park, Taipei, Taiwan

"Beyond the Frontier of Color and Form – Subversion and Reconstruction", Main Trend Gallery,
 Taipei, Taiwan

2006 "Taipei / Taipei: Views and Points", Taipei Fine Arts Museum, Taipei, Taiwan

2005 "Heroes of Kuandu: Taiwan Contemporary Art Exhibition", Kuandu Museum of Fine Arts, Taipei, Taiwan

"Linear Writing", Taipei Fine Arts Museum, Taipei, Taiwan

2004 "The Lyricism of Form Geometric Abstraction", Taipei Fine Arts Museum, Taipei, Taiwan

"Artists Festival", Huashan Arts Distrtct, Taipei, Taiwan

"The Multiform Nineties: Taiwan's Art Branches", Taipei Fine Arts Museum, Taipei, Taiwan

2003 "Soul Reconstruction, Part III – Joint Exhibition Celebrating Life", Taipei Fine Arts Museum, Taipei,
 Taiwan

"Discourses on Love: 64 Conversations in SARS' Era", IT Park, Taipei, Taiwan

"My Name", Minghsin University of Science and Technology, Hsinchu, Taiwan

2002 "Contemporary Art in Taiwan", Hong-gah Museum, Taipei, Taiwan

"A Vital Illusion", IT Park, Taipei, Taiwan

"Faraway Reality", IT Park, Taipei, Taiwan

2001 "The Gravity of The Immaterial: Opening Exhibition", Museum of Contemporary Art Taipei, Taipei, Taiwan

"The Opening Exhibition: Sailing to A New Era", Main Trend Gallery, Taipei, Taiwan

2000 "Spectacular Waves Beating the Shore / 100 Years of Taiwan Fine Art", Kuandu Museum of Fine art, Taiwan

1999 "Magnetic Writing – Marching Ideas Works on Paper", IT Park, Taipei, Taiwan

1998 "The Man Come from Hometown", Bamboo Curtain Studio, Taipei, Taiwan

"In the Back Yard of Taipei City: The Installation Exhibition Homeland – Take A Break and Be Right Back", Grass Mountain Chateau, Taipei, Taiwan

"A Banquet – Moths Darting into the Flame: 10th Anniversary Celebration of Taiwan Museum of Art", Taiwan Museum of Art, Taichung, Taiwan

"A Story of River Bed", Enlighten the Canal Taiwan Culture Center, Tainan, Taiwan

1997 "Exhibition by IT Park and Taipei Fine Art Museum", Taipei Fine Art Museum, Taipei, Taiwan

"The Opening Exhibition – Reconstructing the Chaotic", YilamTiam Art Center, Kaohsiung, Taiwan

1996 "The Black Society", The Dimension Art Foundation Gallery, Taipei, Taiwan

"Taipei Biennial: The Quest for Identity – Backyard Garden in Jun", Taipei Fine Arts Museum, Taipei, Taiwan

"The Independent Declaration", Lin & Keng Gallery, Taipei, Taiwan

"The Ceramic Group Exhibition – A Space not for the Chorus", Taipei County Culture Center, Taipei, Taiwan

1995 "The Southern Way", Leisure Art Center, Taipei, Taiwan

"Transitional Site", IT Park, Taipei, Taiwan

1994 "Dialogue Between Creation and Material", Home Gallery, Taipei, Taiwan

"Wandering", IT Park, Taipei, Taiwan

"Urban Nature", The Dimension Art Foundation Gallery, Taipei, Taiwan

"Texture", Number 2 Space, Taipei, Taiwan

"Monochrome", Gallery Elegance, Taipei, Taiwan

"The Indescribable Unknown – The IT Park Fund Raising Exhibition", IT Park, Taipei, Taiwan

1993 "Stopping the World", IT Park, Taipei, Taiwan

"An Idea About Flowers", IT Park, Taipei, Taiwan

"Tradition and Creation – Chinese Floral Arts Foundation", Taipei World Trade Center, Taipei, Taiwan

"The Subtropical Plant", The Eslite Vision, Taipei, Taiwan / Galerie Pierre, Taichung, Taiwan

"Tsong Pu, Lai Chun-Chun, Hul Kun-Jung, Three-Man Exhibition", IT Park, Taipei, Taiwan

"Culture of Gift Giving", New Phase Art Space, Tainan, Taiwan

"IT Kitsch – A gift of love", IT Park, Taipei, Taiwan

1992　"Art Expo", Sung-Shan Exhibition Hall, Taipei, Taiwan

"Banquent of Awa Wearing the Symbol", IT Park, Taipei, Taiwan

"Environment & Art – 16 Ideas of Rubbish Handing", Taipei Municipal Culture Center, Taipei, Taiwan

"The Taipei Biennial of Contemporary Art", Taipei Fine Arts Museum, Taipei, Taiwan

"Beginning from the Object", IT Park, Taipei, Taiwan

"Taiwania Gallery Opening Exhibition", Taiwania Gallery, Taiwan, Taiwan

1991　"Sorcery Exhibition", IT Park, Taipei, Taiwan

"International Mail Art Exhibition", IT Park, Taipei, Taiwan

"Installation in the Eslite Book Store", The Eslite Book Store, Taipei, Taiwan

"Contemporary Art Trends in the R.O.C. 1991", Leisure Art Center, Taipei, Taiwan

"The Space between the Metaphysical and the Material", Up Art Center, Kaohsiung, Taiwan

"Twelve – Man Contemporary Paintings Exhibition", Dimensions Art Gallery, Taipei, Taiwan

1990　"Poems and the New Environment", Eslite Gallery, Taipei, Taiwan

"Up Art Gallery Opening Exhibition", Up Art Gallery, Kaohsiung, Taiwan

"Selected Exhibition of 300 Years of Taiwan Art Work", Taiwan Museum of Art, Taichung, Taiwan

"Yung-Han Gallery Opening Exhibition", Yung-Han Gallery, Taipei, Taiwan

"IT Park Gallery Opening Exhibition", IT Park, Taipei, Taiwan

"Contemporary Artists Drawing Exhibition", Eslite Gallery, Taipei, Taiwan

1988　"Joint exhibition of Tsong Pu and Chu The-I", Eslite Gallery, Taipei, Taiwan

"Media, Environment and Installations", Taiwan Museum of Art, Taichung, Taiwan

"Time and Creation Exhibition", Taipei Fine Arts Museum, Taipei, Taiwan

1987　"Avant-Garde Installation Space", Taipei Fine Arts Museum, Taipei, Taiwan

"Chinese Contemporary Paintings", National Museum of History, Taipei, Taiwan

1986　"SOCA Studio Opening Exhibition", SOCA Studio, Taipei, Taiwan

"Contemporary Art Trend in the R.O.C.", Taipei Fine Arts Museum, Taipei, Taiwan

1985　"Avant Grande · Installation Space Exhibition ", Taipei Fine Arts Museum, Taipei, Taiwan

"Taipei Hsiung Shih Biennial Exhibition", Hsiung Shih Gallery, Taipei, Taiwan

"Transcendent – Play of Space II", Spring Gallery, Taipei, Taiwan

1984　"Alien – Play of Space", Spring Gallery, Taipei, Taiwan

1983　"New Form Art Center Opening Exhibition", New Form Art Center, Taipei, Taiwan

"Taipei Fine Arts Museum Opening Exhibition", Taipei Fine Arts Museum, Taipei, Taiwan

1982　"Three-Man Exhibition", Spring Gallery, Taipei, Taiwan

1979 "Contemporary Overseas Chinese Artists", National Museum of History, Taipei, Taiwan

International Group Exhibitions

2023 "Worldly Existence – Habitat, 1980s Taiwan Artists Joint Exhibition", Albergue SCM, Macau, China

2021 "The 29th Asian International Art Exhibition", Kyushu Geibun-kan, Fukuoka, Japan

2015 "Tsong Pu's Twelve Monologues – Multicolored Bamboo", Beijing Art Now Gallery, Beijing

2014 "We Have Never Participated, The 8th Shenzhen Sculpture Biennale", OCT Contemporary Art Terminal (Shenzhen), Shenzhen, China

2012 "27th Asian International Art Exhibition", Ratchadamnoen Contemporary Art Center, Bangkok, Thailand

2011 "26th Asian International Art Exhibition", Hangaram Art Museum of Seoul Arts Center, Seoul, Korea

"Dual Senses and Dynamic Views – Contemporary Art Exhibition across the Taiwan Straits of 2011", National Art Museum of China, Beijing, China

2009 "Exhibition by Tsong Pu and Wu Tien Chang", ART BEIJING 09 (Agricultural Exhibition Center Booth A9 & A10), Beijing, China

"First Connect: Contemporary Art Exhibition – Taipei, Kunming, Hong Kong", 99 Art space, Kunming, China

2008 "Art is Alive", Busan Biennale 2008, Busan Museum of Modern Art, Busan, Korea

2006 "Le Salon 2006", Grand Palais, Paris, France

"PASS", Nagoya University of Arts, Nagoya, Japan

"Art Trend in Taiwan, 1950~2000", National Art Museum of China, Beijing, China

2005 "Taiwan Modern Art Exhibition", Kunming City Museum, Kunming, China

2004 "Taiwan Contemporary Art Exhibition", Diocesan Museum of Barcelona, Barcelona, Spain

2002 "Chinese Ink Tree / Cambio Constante III", Monasterio de Veruela, Zaragoza, Spain

"Encounter Over Seas: Physical Transplanting the Historical", Old Ladies' House Gallery, Macau, China

"P_A_U_S_E – Gwangju Biennale 2002", "PAUSE – Gwangju Biennale, Gwangju, South Korea

2001 "Taipei Contemporary Art Exhibition", Shanghai Museum of Modern Art, Shanghai, China

2000 "A the Game of Words", University Buffalo Art Gallery, U.S.A

1999 "Visions of Pluralism: Contemporary Art in Taiwan, 1988-1999", National Art Museum, Beijing, China,

1998 "Masters of Today and Young Artists Exhibition – Special 40th Anniversary Exhibition", Paris, France

"International Sculpture Symposium – You are the End, I am the Stone, and He is the Bone", Guilin Uzi Paradise, China

"Inside Out / New Chinese Art", P.S.1. Contemporary Art Center, New York, U.S.A / San Francisco Contemporary Art Museum, U.S.A

1997 "Segmentation / Multiplication – Three Taiwanese Artists", 47th International Venice Biennial Exhibition, Venice, Italy

1996 "Journey to the East 97: Installation Arts from Beijing, Shanghai, Taipei and Hong Kong", Hong Kong, China

"Taipei Contemporary Art Exhibition", Shanghai City Arts Museum, Shanghai, China

1995 "Taiwan Contemporary Art Exhibition", Australia

1994 "Taipei Modern Art Exhibition", The National Gallery, Bangkok, Thailand

"Taipei Contemporary Art Exhibition", Portside Gallery, Yokohama, Japan

1989 "Message from Taipei", Hara Museum of Contemporary Art, Tokyo, Japan

1987 "Chinese Contemporary Paintings", National Museum of Contemporary in Seoul, Korea

1986 "The Invitational Exhibition from the International Modern Arts Association Japan", Yokohama, Japan

1980 "China-Japan Two-People Exhibition", Sala de Exposiciones de la Delegacion Provincial de Turismo, Santander, Spain

"Two-People Exhibition", Galería Itxaso, Zaragoza, Spain

1979 "Group Exhibition of Chinese Artists in Europe", Galería Kienlong, Brussels, Belgium

"Three-Man Exhibition," Galería El Buscon, Spain

"Three-Man Exhibition," Galería Rincon de Arte, Madrid, Spain

Collectible Records

2021 *Imbibing Circuit, The Poetics of the Quotidian, Seven Days of Practice, The Monument of Labour, Spirit Tower*, New Taipei City Art Museum, New Taipei, Taiwan

1997 Monument, Amphitheater of Hands, National Taiwan Museum of Fine Arts, Taichung, Taiwan

Enticing Encounter II, Hanging, Kingdom of Disillusion, You are the beautiful flower, Beyond the Yardstick, A Cloud A Stone A Tree, Flowers within Concrete, Taipei Fine Arts Museum, Taipei, Taiwan

2020 *Illusions of the Universe, Brightness, So Near and Yet So Far*, Taipei Fine Arts Museum, Taipei, Taiwan

2019 *Seaport Sun*, Kaohsiung Museum of Fine Arts, Kaohsiung, Taiwan

2018 *Eyes of Utux, Divided Path*, National Taiwan Museum of Fine Arts, Taichung, Taiwan

2010 *Backyard in June, In a Distant Snoring Sound*, Performing Light, Taipei Fine Arts Museum, Taipei, Taiwan

2009 *Shinning Meet*, National Taiwan Museum of Fine Arts, Taichung, Taiwan

2000 *Turning Wind*, Kaohsiung Museum of Fine Arts, Kaohsiung, Taiwan

1998 *Rambling Everywhere*, National Taiwan Museum of Fine Arts, Taichung, Taiwan

1995 *Secret Decoration – Zirconium, Self-Portrait*, Taipei Fine Arts Museum, Taipei, Taiwan

1994 *Transposition, Rap Factory*, Minato Gallery, Yokohama, Japan

1992 *Transposition of Light and Water*, Taipei Fine Arts Museum, Taipei, Taiwan

1989 *Unknown*, Hara Museum of Contemporary Art, Tokyo, Japan

Black and White, Taipei Fine Arts Museum, Taipei, Taiwan

1984 *A Trembling Line*, Taipei Fine Arts Museum, Taipei, Taiwan

Public Art

2010 *New Waves*, Southern Coastal Patrol Office, Coast Guard Administration, Executive Yuan, Kaohsiung, Taiwan

2008 *The Chink of Light*, Taipei Rapid Transit Corporation – Taipei Nangang Exhibition Center, Taipei, Taiwan

2006 *The Scientist Said:*, National Nano Device Laboratories, Hsinchu, Taiwan

2005 *Five Riverbeds*, Garage and Recycling squads, Department of Environmental Protection, Taipei City Government, Taipei, Taiwan

Stairs of history, Taiwan Area National Freeway Bureau, MOTC – Cingshui Service Area, Taichung, Taiwan

2004 *The Art of Speed*, National Taiwan University Sports Center, Taipei, Taiwan

Scenery with Comma and Dot, Nankang Software Park, Taipei, Taiwan

The Artist Said, Taipei National University of The Arts, Kuandu Museum of Fine Arts, Taipei, Taiwan

2003 *Global Circle*, Taipei 101 Financial Center, Taipei, Taiwan

Drinking Fountain, Neihu Sewage Treatment Plant, Taipei, Taiwan

1998 *Musical Skies*, Taipei Rapid Transit Corporation – Chiang KaiShek Memorial Hall Station, Taipei, Taiwan

作品索引
Index of Works

1977-1989

Page 68	無題，1977-1982，素描，105×75公分，李道明收藏。	*Untitled*, 1977-1982, sketch, 105×75 cm. Collection of Lee Daw-Ming.
Page 69	五張貼紙，1978，素描，93×75公分，李道明收藏。	*Five Stickers*, 1978, sketch, 93×75 cm. Collection of Lee Daw-Ming.
Page 169	消散的近景，1982，油彩畫布，190×130公分，私人收藏。	*Dissipation Close-Up*, 1982, oil paint on canvas, 190×130 cm. Private collection.
Page 192	邂逅後的誘惑 *II*，1985，壓克力顏料、畫布，131×382公分，私人收藏。	*Enticing Encounter II*, 1985, acrylic on canvas, 131× 382 cm. Private collection.
Page 128	來去自如遨遊四方，1985，不鏽鋼，尺寸依場地而定，藝術家提供。	*Nomadic,* 1985, stainless steel, dimensions variable. Courtesy of the artist.
Page 59	月落・日出，1986，鐵板、鐵鋏，100×50×90 公分，藝術家提供。	*Moonset, Sunrise,* 1986, iron plate, iron clip, 100× 50×90 cm. Courtesy of the artist.
Page 60	一串月圓，1986，鐵板、麻繩，207×230×44公分，藝術家提供。	*A String of Full Moons*, 1986, iron plate, hemp rope, 207×230×44 cm. Courtesy of the artist.
Page 63	日出・日落，1986，鐵板、鋁板、鐵鋏，150×150×150公分，藝術家提供	*Sunrise, Sunset*, 1986, iron plate, aluminum plate and iron clip, 150×150×150 cm. Courtesy of the artist.
Page 177	掛著，1989，樹枝、麻繩、壓克力顏料、畫布，29×40×9公分，臺北市立美術館典藏。	*Hanging,* 1989, branch, hemp rope Acrylic on canvas, 29×40×9 cm. Collection of Taipei Fine Arts Museum.

1990-1999

Page 185	五月,1990,角鐵、陶土,尺寸依場地而定,藝術家提供。	***May,*** 1990, angle iron, pottery clay, dimensions variable. Courtesy of the artist.
Page 136	蠻荒原質,1991,複合媒材,38.5×45.5×8.5公分 ×2件,藝術家提供。	***Primal Wilderness***, 1991, mixed media, 38.5×45.5×8.5 cm×2 pieces. Courtesy of the artist.
Page 176	幻滅之國,1992,竹子、壓克力顏料、畫布,43.5×46.5×5公分,臺北市立美術館典藏。	***Kingdom of Disillusion***, 1992, bamboo,acrylic on canvas, 43.5×46.5×5 cm. Collection of Taipei Fine Arts Museum
Page 64, 186-189	逃離現場,1992,木材,尺寸依場地而定,藝術家提供。	***Escape the Scene***, 1992, wood, dimensions variable. Courtesy of the artist.
Page 65	真愛不滅,1993,電影海報、蠟筆,104×71公分,藝術家提供。	***True Love Never Disappear,*** 1993, movie poster, crayon, 104×71 cm. Courtesy of the artist.
Page 182	**1997 紀念碑**,1996,水泥、木桌椅、展台,166×170×58公分,國立臺灣美術館典藏。	**1997 *Monument***, 1996, cement, chair, table and stand, 166×170×58 cm. Collection of National Taiwan Museum of Fine Arts
Page 132	你就是那美麗的花朵,1997,複合媒材裝置,尺寸依場地而定,藝術家提供。	***You are the Beautiful Flower***, 1997, mixed media installation, dimensions variable. Courtesy of the artist.
Page 206	仗凝・時見,1999,壓克力顏料、畫布,193.5×130公分 ×2件,私人收藏。	***Of an Imposing Manner, Seeing Frequently***, 1999, acrylic on canvas, 193.5×130 cm×2 pieces. Private collection.
Page 190	轉風,1999,壓克力顏料、畫布,218×290公分,高雄市立美術館典藏。	***Veering Wind***, 1999, acrylic on canvas, 218×290 cm. Collection of Kaohsiung Museum of Fine Arts.

Page 200	因觀，1999，壓克力顏料、畫布，218×290公分，誠品畫廊提供。	**Perceiving Cause**, 1999, acrylic on canvas, 218×290 cm. Collection of Eslite Gallary.
Page 201	霜彩，1999，壓克力顏料、畫布，218×290公分，誠品畫廊提供。	**The Color of Frost**, 1999, acrylic on canvas, 218×290 cm. Collection of Eslite Gallary.

2000-2009

Page 112	**N96**，2003，攝影、溫度計，31×21×2.7公分 ×15件，藝術家提供。	**N96**, 2003, photograph, thermometer, 31×21×2.7 cm×15 pieces. Courtesy of the artist.
Page 147	在遼闊的打呼聲中，2005，複合媒材裝置，尺寸依場地而定，臺北市立美術館典藏。	**In a Distant Snoring Sound**, 2005, mixed media installation, dimensions variable. Collection of Taipei Fine Arts Museum.
Page 194	我討厭村上隆 我討厭奈良美智，2008，木材、布袋、壓克力顏料，175×90×170公分，王行恭收藏。	**I Hate Takashi Murakami, I Hate Yoshitomo Nara**, 2008, wood, acrylic on cloth bag, 175×90×170 cm. Collection of David Wang Hsin Kong.
Page 164	閃耀的交會，2008，壓克力顏料、畫布，200×300公分，國立臺灣美術館典藏。	**Shinning Meet**, 2008, acrylic on canvas, 200×300 cm. Collection of National Taiwan Museum of Fine Arts.

2010-2019

Page 126	迷走的白色花園，2010，鋅鐵，200×390公分，藝術家提供。	**Wandering in White Garden**, 2010, iron, 200×390 cm. Courtesy of the artist.
Page 202	新店男孩（陳順築、莊普、吳東龍、蘇匯宇），**生活的決心**，2012，單頻道錄像、攝影、裝置作品，尺寸依場地而定，臺北市立美術館典藏。	Xindian Boys (Chen Shun-Chu, Tsong Pu, Wu Dong-Lung, Su Hui-Yu), **The Determination of Life**, 2012, single-channel video, digital print and installation, dimensions variable. Collection of Taipei Fine Arts Museum.

Page 131	白色蝴蝶，2021，壓克力顏料、代針筆、畫布，60.5×72.5公分，藝術家提供。	*White Butterfly*, 2021, acrylic and pigment pen on canvas, 60.5×72.5 cm. Courtesy of the artist.
Page 102-111	手的競技場，2021，複合媒材，49.6×84.1×3.6公分 ×30件，國立臺灣美術館典藏。	*Amphitheater of Hands*, 2021, mixed media, 49.6×84.1×3.6cm×30 pieces. Collection of National Taiwan Museum of Fine Arts
Page 124	三竹節，2022，鍍鋅、角鋼，尺寸依場地而定，藝術家提供。	*Three Bamboo Joints*, 2022, galvanized on angle steel, dimensions variable. Courtesy of the artist.
Page 70	靈韻，2022，壓克力顏料、畫布，72.5×60.5公分，藝術家提供。	*Spiritual Rhythm,* 2022, acrylic on canvas, 72.5×60.5 cm. Courtesy of the artist.
Page 71	終極的實在，2022，壓克力顏料、畫布，72.5×60.5公分，藝術家提供。	*The Ultimate Reality*, 2022, acrylic on canvas, 72.5×60.5 cm. Courtesy of the artist.
Page 72	遠方的眼淚，2022，壓克力顏料、畫布，72.5×60.5公分，藝術家提供。	*Faraway Tears*, 2022, acrylic on canvas, 72.5×60.5 cm. Courtesy of the artist.
Page 73	黑色逗點的轉移，2022，壓克力顏料、畫布，72.5×60.5公分，藝術家提供。	*Transition of a Black Comma*, 2022, acrylic on canvas, 72.5×60.5 cm. Courtesy of the artist.
Page 80	生日，2022，壓克力顏料、畫布，72.5×60.5公分，藝術家提供。	*Birthday*, 2022, acrylic on canvas, 72.5×60.5 cm. Courtesy of the artist.
Page 81	水仙花，2022，壓克力顏料、畫布，72.5×60.5公分，藝術家提供。	*Daffodils*, 2022, acrylic on canvas, 72.5×60.5 cm. Courtesy of the artist.
Page 120	藍色的消遣，2022，壓克力顏料、畫布，72.5×60.5公分，藝術家提供。	*The Dissolution of Blue*, 2022, acrylic on canvas, 72.5×60.5 cm. Courtesy of the artist.

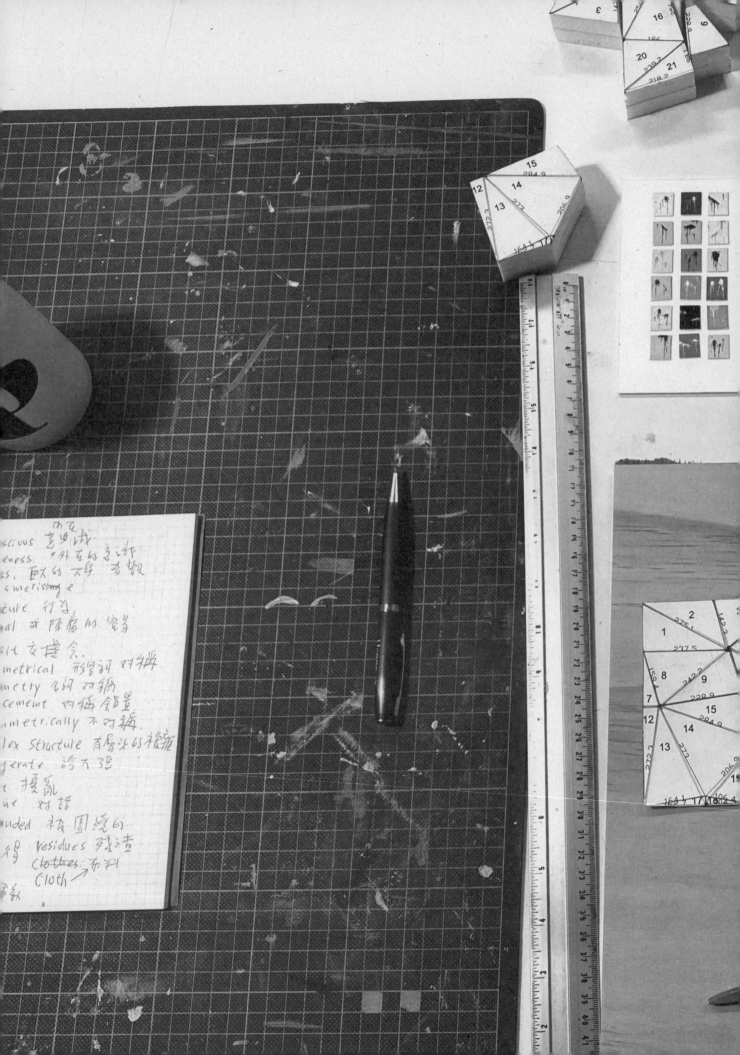

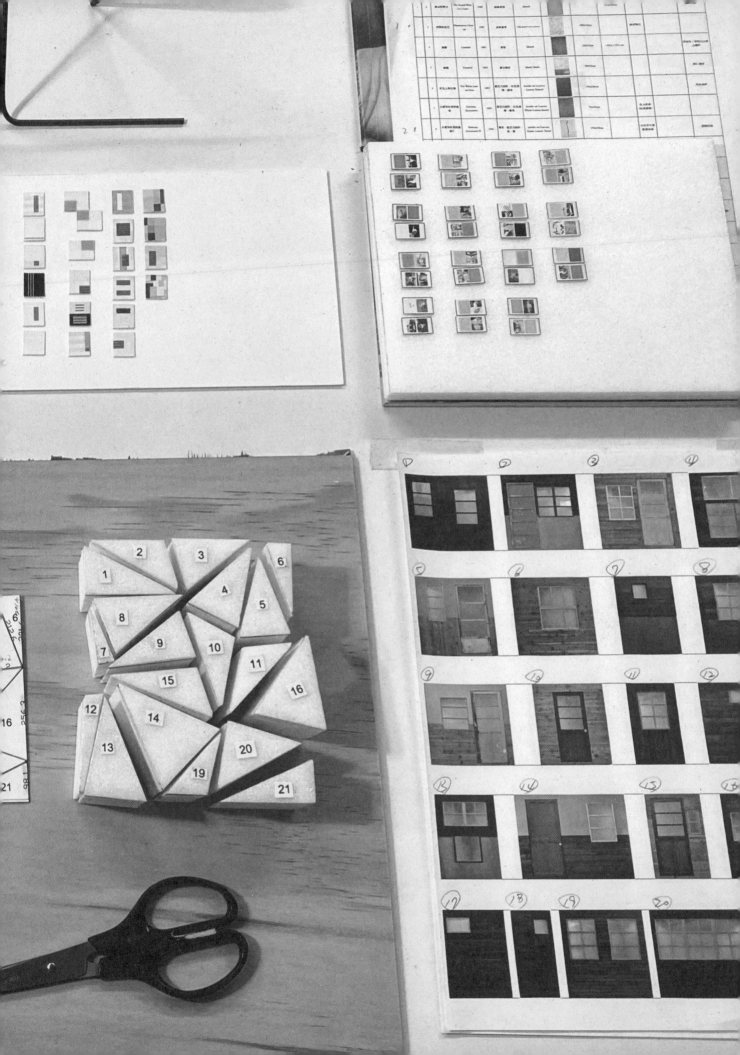

越野的靈光：莊普個展
Tsong Pu : Off-Road Aura

指導單位 Supervisor
文化部 Ministry of Culture

主辦單位 Organizer
國立臺灣美術館 National Taiwan Museum of Fine Arts

發行人 Publisher
陳貺怡 Chen Kuang-Yi

編輯委員 Editorial Committee
汪佳政、亢寶琴、黃舒屏、蔡昭儀、林明賢、賴岳貞、
駱正偉、尤文君、曾淑錢、吳榮豐、粘惠娟
Wang Chia-Cheng, Kang Pao-Ching, Iris Shu-Ping Huang,
Tsai Chao-Yi, Lin Ming-Shien, Lai Yueh-Chen, Luo Zheng-Wei,
Yo Wen-Chun, Tseng Shu-Chi, Wu Rong-Feng, Nien Hui-Chuan.

總編輯 Chief Editor
汪佳政 Wang Chia-Cheng

策展人 Curator
石瑞仁 Shih Jui-Jen

主編 Editor
黃舒屏 Iris Shu-Ping Huang

執行編輯 Executive Editors
黃詠純、何宗游、王俞方、賴姿伃
Huang Yung-Chun, Ho Thung-Yu, Wang Yu-Fang, Lai Tzu-Yu

視覺與書籍設計 Graphic & Book Designer
紙霧視覺設計工作室 PaperFog Design Studio

美術編輯 Layout Designer
曲秀娥 Chu Hsiu-E

展覽執行 Exhibition Coordinators
黃詠純、何宗游、莊普藝術工作室
Huang Yung-Chun, Ho Thung-Yu, Tsong Pu Art Studio

空間設計 Exhibition Design
景三空間設計制作所 SHADOW Design Studio

影音暨燈光技術執行 Technical & Lighting Executive
牧咺有限公司 l'atelier muxuan

布展執行 Installation Team
翔輝運通股份有限公司 Sunway Express Co., Ltd

展場攝影 Photography
王世邦 ANPIS FOTO

翻譯 Translators
王聖智、馬思揚、黃亮融、蘊藝術工作室
Wang Sheng-Chen, Ma Shih-Yang, Alex Huang, Yun Art Studio

展覽日期 Exhibition Date
2023 年 10 月 28 日至 2024 年 2 月 18 日
October 28, 2023 – February 18, 2024

出版單位 Publisher
國立臺灣美術館 National Taiwan Museum of Fine Arts

地址 Address
臺中市 403414 西區五權西路一段 2 號
No.2, Sec. 1, Wu-Chuan W. Road, 403414,Taichung, Taiwan, R.O.C.

電話 TEL
04-23723552

傳真 FAX
04-23721195

www.ntmofa.gov.tw

印刷 Printer
日動藝術印刷有限公司 Sunrise Art Printing Co.,Ltd.

出版日期 Publishing Date
2023 年 11 月 November 2023

ISBN
978-986-532-929-7

GPN
1011201372

定價 Price
新臺幣 NT$ 850 元

國家圖書館出版品預行編目 (CIP) 資料

越野的靈光：莊普個展 Tsong Pu : Offf-Road Aura
黃舒屏主編. — 初版. — 臺中市：國立臺灣美術館, 2023.11
240 面；21×28公分
ISBN 978-986-532-929-7（精裝）
1.CST: 藝術 2.CST: 作品集
902.33 112017388